IMAGES
of America

MILLIS

Waites Felting Mill, – has been located here since the old mill burned down in 1884
The buildings now standing were built in and business has kept the mill from shutting down for lack of orders. There is manufactured here felt for all kinds of cheap goods. Most anything of a fibre nature is used, just wool enough to hold stock together from spliting after its being made.
Stock used, – all grades of wool; soiled, burnt, waste, oily & cotton; shoddy (torn up felt) card waste; tared wool; sweepings from other mills; and dusty, dirty stock of a fibre nature.
There is very little new machinery, most all the carding and to the finished end being old machinery. The dryer being a decidely new machine, in putting this dryer in, part of the card room being taken up for its room, thus shutting out about thirty feet of lighted windows, making it very unconvient for formers tenders for loss of light & added extra – heat in summer.
The average amount of stock trimed per week in card room is about 950 lbs, with 5 formers, and 14 breaker cards of various sizes, breakers from 40 to 60 inch, – formers from 72 to 90 inch.
The plant was leased to the American Felt Co. in effect Feb. 1, 1899. for a term of five years. and is owned in name by Mrs E. Waite, of Franklin and Enoch Waite as manager (she his wife) also the Paper mills at Baltimore (in Rockville) and at the place near City Mills called the Bush factory. and some kind of a felt mill in So. Franklin.
The new company commenced by paying weekly on Friday (Lewis Morse as clerk). paid up to a Saturday night and pay given the next Friday. Which was very much apreciated by majority of the help, it being in cash.

Walter Metcalf Prescott lived in Rockville and worked in the felt mill. He was a professional photographer, volunteer fireman, fabric salesman, and chronicled daily life with his photography and by writing in his journal. This page, a thumbnail from his journal, describes the Waite's Mill in Rockville. In particular, he wrote about the machinery, manufacturing, and his coworkers and employers in the mill. (Courtesy of Wayne Simpson.)

ON THE COVER: This 1902 photograph shows the corner of Pleasant and Turner Streets with Waite's Mill in the distance beyond the old wooden bridge. Dipping water from the spring, which still exists, are (from left to right) Curtis Parish with the glass of water, Fred Herd, Emily Irwin, Marion Wright, and John Cribbie. (Courtesy of the Millis Historical Society.)

IMAGES
of America

MILLIS

Charles Vecchi and Elizabeth Krimmel

ARCADIA
PUBLISHING

Published by Arcadia Publishing
Charleston, South Carolina

Printed in the United States of America

Library of Congress Control Number: 2011938717

For all general information, please contact Arcadia Publishing:
Telephone 843-853-2070
Fax 843-853-0044
E-mail sales@arcadiapublishing.com
For customer service and orders:
Toll-Free 1-888-313-2665

Visit us on the Internet at www.arcadiapublishing.com

To all the unsung heroes of preservation, to all those who add sweat equity to a project restoration, to those who slog through paperwork trying to list properties in the National Register, to all those who fight to save buildings from being torn down, and for all those who cherish the history of town and country, we dedicate this book.

CONTENTS

ACKNOWLEDGMENTS

We both—Charlie Vecchi and Beth Krimmel—have been involved in local history for many years. We have served together on the Millis Historical Commission and the Niagara Fire Engine House restoration team, and have helped to successfully list Prospect Hill Cemetery, Millis Center Historic District, Oak Grove Farm House, and Ellice School in the National Register of Historic Places. Working with other team members, we have scraped and painted the Niagara Fire Engine House, watching in awe as the structure became sound again with a new foundation and floor with grant monies secured from the Millis Community Preservation Committee.

This project is the culmination of working in tandem with dedicated volunteers who are interested in the preservation and history of not only their nation, but of their hometown. Not many towns in Massachusetts can boast four historic buildings—Niagara Fire Engine House, Oak Grove Farm, Ellice School, and Old Town Hall and Library—that are all held in the arms of the town; nor can many towns boast of all the open farmland secured for public use. For this, Millis stands proud.

History was documented first through word of mouth and then through the written language. For approximately the past 170 years, history has been documented through the wonderful invention of photography. We are lucky to have so many of the original glass-plate negatives, or Prescott Plates, of early Millis, as well as the personal journal of Walter Metcalf Prescott. We thank the keeper of these gems, Wayne Simpson, for the use of those images in this book. Ellen Rosenfeld graciously allowed us full access to the Hindy Rosenfeld Collection, which is located for public viewing in cases at the town hall. Julius Rosen, Edward "Buddy" Shropshire, and Harold E. Curran kindly allowed use of their private photograph collections, adding depth to the content. We also would like to thank the Millis Historical Society for the use of its extensive photograph collection.

All photographs are courtesy of the Millis Historical Society, unless otherwise noted.

Last but not least, we would like to thank our spouses, Susan Vecchi and Tom Krimmel, for the encouragement to complete the book.

INTRODUCTION

Before European contact, Algonquin-speaking subgroups of the Nipmuck natives, particularly the Natick, lived in the area of present-day Millis along the western bank of the Charles River between Boggastowe Creek, the fording place at Rockville, and the Great Black Swamp. The first mention of Boggastowe appears in the Dedham records of 1640. The land was good farmland because of the Indian custom of burning the fields each fall to provide grazing land for wild game. This enabled the pasturing of animals along meadows and continuous plains in the area.

The Massachusetts General Court incorporated Dedham in 1636. At that time, Dedham was comprised of the towns in present-day western Norfolk County. The Town of Medfield was incorporated in 1649, and encompassed the present-day towns of Medfield, Medway, and Millis.

Medfield was attacked and burned in February 1676 by a native raiding party during King Philip's War. Several houses in what is now Millis were burned. After King Philip (known as *Metacomet* in Algonquin) was killed in August 1676, the war ended. The settlers rebuilt and repaired the damage to their farms and mills with monetary assistance from the provincial legislature.

Settlement continued on land west of the Charles River until 1712, when landowners petitioned the Massachusetts General Court to break from Medfield. On October 25, 1713, Medway was incorporated and formed the areas of present-day Medway and Millis. The following year, a burying place known as Bare Hill was laid out in the eastern part of Medway. It was later to be called the Old Churchyard Cemetery, and is currently known as Prospect Hill Cemetery. It is the only cemetery in Millis, and has remained in active use for nearly 300 years. It is the burial place of many of the town's notable citizens and provides important documentation of the social and military history of the community. Nathan Bucknam, second minister of the Church of Christ Medway, fought in both the French and Indian and Revolutionary Wars. He is buried in the cemetery along with 73 other Revolutionary War soldiers. The cemetery's landscape reflects multiple periods of burial ground design and is characterized by steep wooded slopes, the highest point being at Prospect Hill. The cemetery has distinctive landscape features and monuments from the early 18th century to the present.

The oldest structure in the cemetery may be the meetinghouse steps. A set of 14 dry-laid fieldstone steps leads the way from the road to the top of Prospect Hill, where the original meetinghouse was located. In the early autumn of 1714, the first meetinghouse of the Church of Christ (1714–1749) was erected on the western slope of Bare Hill. Meetinghouses were vital to a town's life, because they held both secular and religious meetings. It was here where the settlers met to worship, conduct town business, and socialize.

The area was dotted with small but prosperous farms. Grist and sawmills were built on Boggastowe Brook and the Charles River at Rockville, in the south end of town. At one time, there were six yards manufacturing bricks. In the period after the Revolutionary War, the area grew. Maj. George Holbrook (1767–1846) was an apprentice to Paul Revere and founded the Holbrook Bell Foundry in East Medway, casting his first bell in 1816. His son Col. George Handel Holbrook

(1798–1875) took over the foundry in 1820. Together, they cast more than 11,000 bells, which were shipped all over the world. In 1830, Holbrook began to manufacture organs. In 1863, James LaCroix started a canning business that eventually employed as many as 150 people.

The town's development is closely associated with the arrival of the railroad line in 1851. There was a short-lived line from Wrentham to Medway that ran through Rockville in the 1850s. A more permanent line was established as the Woonsocket Division of the New York & New England Railroad in the 1850s and 1860s. In 1898, it became part of the New York, New Haven & Hartford Railroad. The line operated through Millis into the 1960s and is still used occasionally from Millis to Needham for freight.

As towns developed, so did the need for fire control. The Niagara Engine Company No. 4 was established in 1857. In the beginning, the engine was housed in a shed behind the Holbrook foundry. In 1879, the Niagara Engine House was completed. A second fire company, Union No. 2, was established in the Rockville area of town.

In 1880, Lansing Millis, a successful railroad executive originally from New York, moved to East Medway. He bought and combined two farms along what is now Exchange Street. He named the combined properties Oak Grove Farm, after a group of trees that still stand on a small hill near the farmhouse. The farm was expanded, and it eventually supplied dairy products throughout the Boston area. Four years later, Lansing Millis, along with Henry LaCroix and Henry Millis, founded the Clicquot Club Ginger Ale and Extracts Company.

On February 26, 1885, the Town of Millis was incorporated and named in honor of Lansing Millis. It was Lansing's son Henry who ushered in Millis's modern industrial era. He expanded the business at Oak Grove Farm, developed residential and industrial properties, and founded the Millis Water Company and the Millis Savings Bank. Other industries, such as the Steel Edge Stamping and Re-tinning Company and the J.W. Thompson Shoe Company (later Herman Shoe Company), followed.

In 1898, the first Jewish family moved to Millis. The Handvergers purchased a small farm in the Rockville section of town. Other Jewish families followed. Some of these families began to take in summer boarders. The Jewish hotel industry was born, with trolleys transporting people from Boston to Millis. With changing lifestyles after World War II, the hotels slowly closed.

Today, the town of Millis has approximately 8,000 residents and retains its small-town character. The town maintains many of the farms that were established in the 18th century. Due to the foresight of the town's residents, the Oak Grove Farm, the Verderber Farm, and other pieces of property have been preserved for public use. This will allow future generations to see and enjoy what those who settled the land so long ago saw in the wonder of our land.

One

THE EARLY YEARS

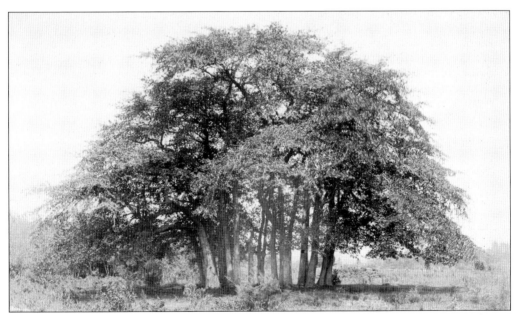

During King Philip's War (1675–1676), the town of Medfield was attacked by native forces. Afterwards, the natives crossed the Charles River (into present-day Millis) over the Great Bridge. They then burned the bridge and rested under a grove of Tupelo trees before attacking the settlers on the west side of the river. The English fled to the palisade near South End Pond, and after a short siege, King Philip's forces retreated. The Tupelo trees still stand off Dover Road.

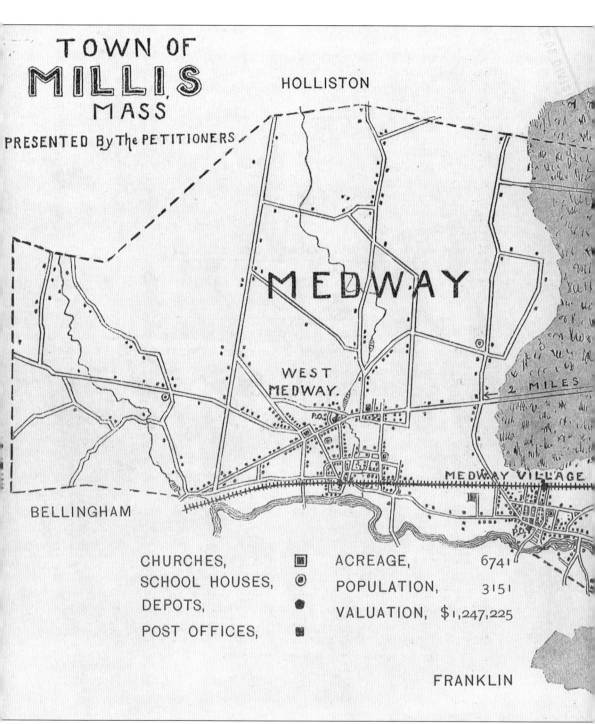

TOWN OF
MILLIS
MASS

PRESENTED By The PETITIONERS

HOLLISTON

MEDWAY

WEST
MEDWAY.

P.O.

2 MILES

MEDWAY VILLAGE

P.O.

BELLINGHAM

CHURCHES,		ACREAGE,	6741
SCHOOL HOUSES,		POPULATION,	3151
DEPOTS,		VALUATION,	$1,247,225
POST OFFICES,			

FRANKLIN

What is now Millis was originally part of Dedham, which was incorporated in 1636. In 1649, thirteen families petitioned for a new town. Lands granted on both sides of the Charles River were incorporated as Medfield in 1651. These lands were called "the old grant." Additional lands were later added to the west, and these new lands were called "the new grant." Settlement continued on land west of the Charles River until 1712, when landowners petitioned the Massachusetts

SHERBORN

BLACK SWAMP

MILLIS

Woonsocket Division
N. Y. & N. E. R.R.

P.O

N

LA CROIX. Del.

NORFOLK

ACREAGE,	6,414
POPULATION,	805
VALUATION,	$405,910

General Court to break from Medfield. On October 25, 1713, Medway was incorporated and formed the areas of present-day Medway and Millis. By 1884, residents of the eastern portion of Medway, or East Medway, petitioned the Massachusetts General Court for separation. The petition was granted on February 24, 1885, and Millis was born. This map shows the proposed division used by the petitioners.

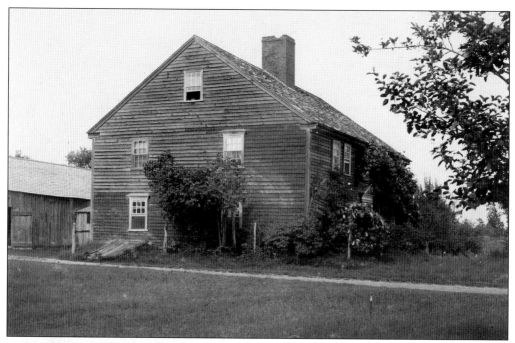

The Jonathan Adams house was burned during King Philip's raid in 1676. John Fussel died in this attack, and was the only casualty in what is known as Millis. The house was rebuilt and located on Union Street across from the factories. It was dismantled and moved to Lancaster, Massachusetts, in the early 2000s.

Dinglehole, a kettle hole pond, is located at the corner of Ridge and Union Streets. In the 1690s, witch hysteria gripped New England, and Millis was no exception. Local legend indicates that there was an old woman who was suspected of being a witch. This woman lived near the pond and was associated with strange happenings and sounds—like a tinkling or dinging of a bell—thus its name, Dinglehole. (Courtesy of Hindy Rosenfeld Collection.)

There are various sites in Millis where very old trenches have been found. Referred to as "Indian trenches," they have been studied by various archaeologists, including A.D. Wyman of Harvard University's Peabody Museum in 1903. It has never been conclusively established who dug the trenches, whether they were natives or settlers. This photograph shows Willard "Deb" Roche (left) and Frank Porter examining the trench near South End Pond. The trenches at South End Pond were lost in the 1960s.

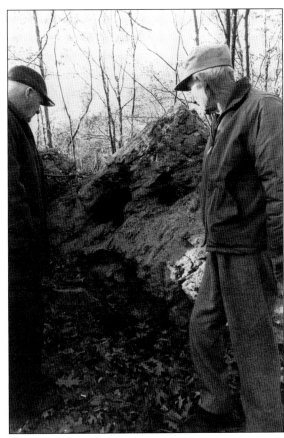

The town meeting records of Medway indicate that £100 was granted on November 23, 1713, for the work of building a meetinghouse. The location of the meetinghouse was on Bare Hill, located on the south side of the cemetery in East Medway a little north of the public tomb. The first meetinghouse burned in 1749, but this stone marks its location.

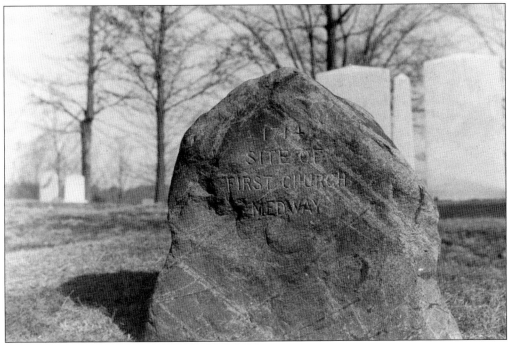

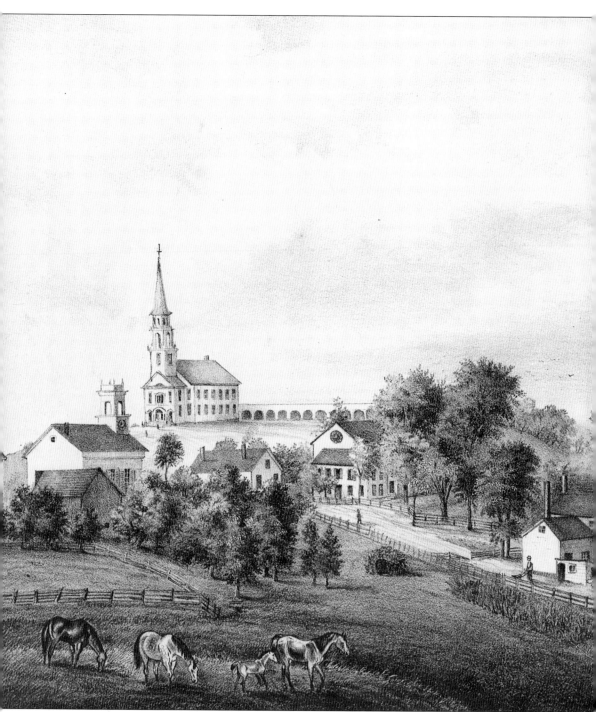

By 1850, East Medway was bustling. This engraving shows the third meetinghouse (1815–1850) on Bare Hill. In 1850, the meetinghouse was sold, taken apart, and moved (without the spire) to the Deanville section of Rockville. This allowed the railroad to cut through Bare Hill, as the rail line ran from Needham to West Medway opened in 1861. In 1816, a bell was needed for the third church in East Medway. Maj. George Holbrook (1767–1846), who apprenticed with Paul

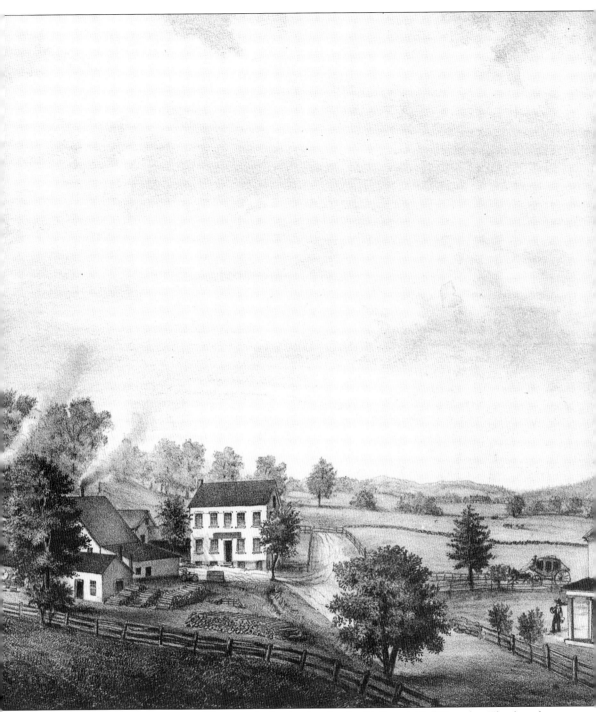

Revere, secured the contract. This was the beginning for the Holbrook Bell Foundry. The foundry is pictured as the group of buildings with the chimneys. Before the foundry closed, 11,000 bells were cast. They were shipped all over the world and hung in Harvard, Yale, and Dartmouth Universities, to name a few.

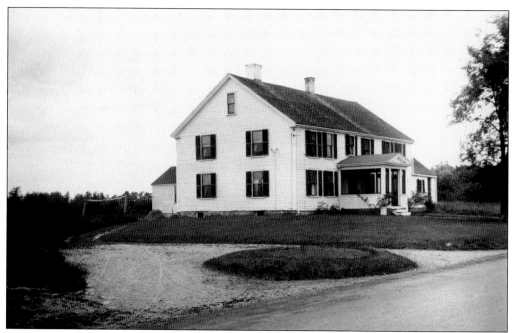

This photograph shows what was once known as Ye Olde Moses Richardson Tavern, which stood on Mendon Road. Legend has it that George Washington dined in the tavern on his way to Cambridge, Massachusetts, in 1775. The house, built around 1720, is situated on Village Street. (Courtesy of Wayne Simpson.)

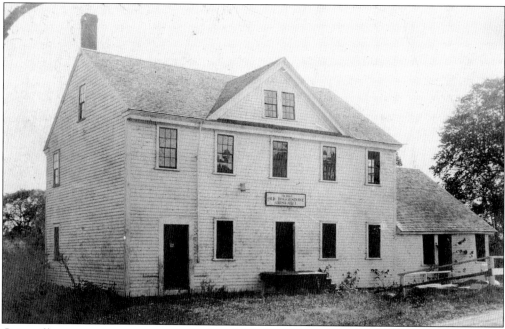

Gristmills were an important part of colonial life. Locally grown grain had to be ground nearby for flour to be used in staples. There were at least three gristmill sites in the area in the 17th and 18th centuries. Boggastowe Gristmill stood on Orchard Street at Boggastowe Pond but burned in the early part of the 20th century.

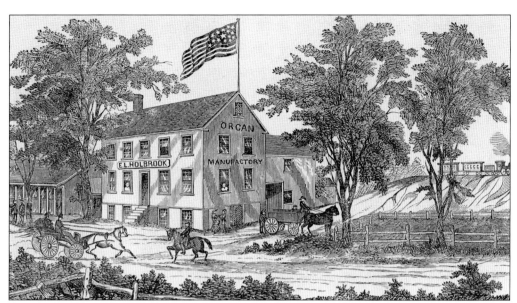

George Handle Holbrook (1798–1875) took over his father's bell foundry in 1820. He expanded in later years to manufacture pipe organs and clocks. The organ factory was established in 1837 and located at the corner of Auburn and Main Streets.

Lansing Millis was born in 1823 in Lansingburgh, New York. In 1855, he moved to Boston and began a career as a railroad executive. He purchased farmland in East Medway and established Oak Grove Farm in 1880. Millis was one of the men who initiated the split with Medway. He was chosen as the first moderator for the town and elected chairman of the board of selectmen but died suddenly on April 6, 1885.

17

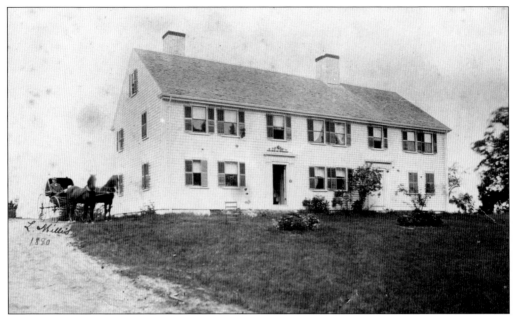

This 1880 photograph of the Oak Grove Farmhouse shows Lansing Millis in his carriage. Millis, his wife, Harriet, and their family lived in the house for three years while building a new home on Island Road. The house was then used to board farmworkers. The section of the house on the right is the oldest part, dating from the early-18th century.

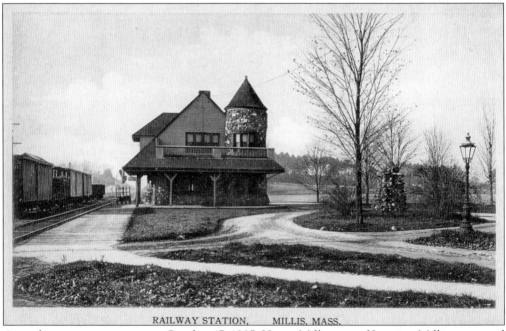

RAILWAY STATION, MILLIS, MASS.

According to town reports, on October 17, 1885, Henry Millis, son of Lansing Millis, requested the intentions of his father be honored by ". . . a building which the said heirs propose to erect with the three-fold object in view of providing a passenger depot in the lower story, and town offices and a room for a public library in the upper story." The white buildings in the distance are Buttercup Farm. (Courtesy of Hindy Rosenfeld Collection.)

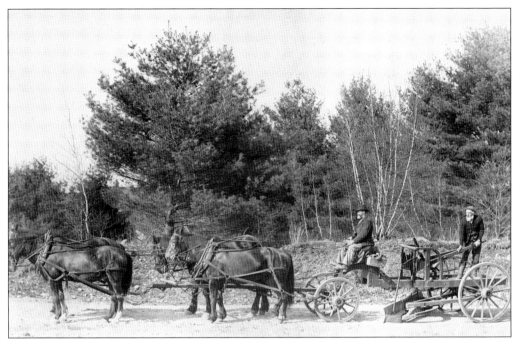

One of the first purchases the town made was for a Champion Road Machine. Referring to the machine, the first Millis annual report states, "it is already more than paid for itself is the testimony of those competent to judge." The driver is Putnam Clark, and the operator is John Hutchins. (Courtesy of Hindy Rosenfeld Collection.)

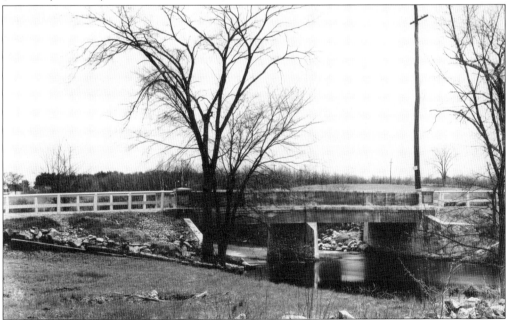

When the Baltimore Paper Mill was active, there were two bridges on Norfolk Road—one went over the river, and the other went over the mill's sluice way. After the Baltimore Paper Mill was demolished, the sluice way was filled. This concrete bridge, shown in this 1920 photograph, replaced the wooden bridge that crossed over the river.

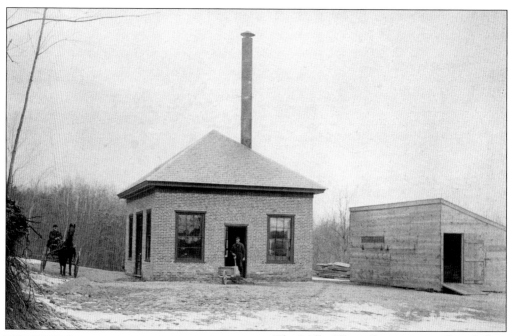

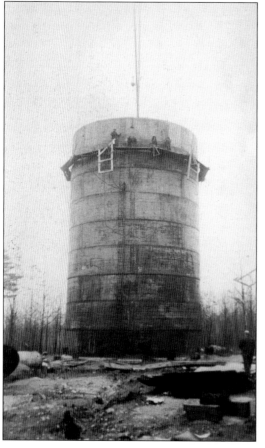

The Millis Water Company was founded by Henry Millis in 1890. At the fourth town meeting on December 15, 1894, the town voted to appropriate $28,000 to purchase the Millis Water Company and $2,000 for a new engine to operate the pumps. This action formed the Millis Water Department. J.S. Adams, the man in the door, was the engineer and earned $532.50 per year.

The new standpipe was started in 1935 on Farm Street. It was built by the Chicago Bridge and Iron Works, which used funds from the New Deal through the Projects Work Administration (WPA), for a total cost of $25,115.

Two

FARMS

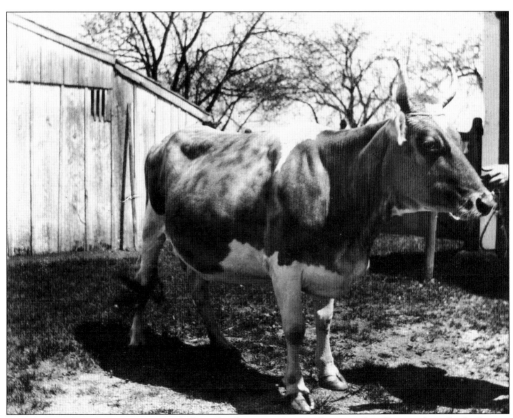

At first, Medfield farmers crossed the Charles River to cut hay on the "longe plain," which was located along Exchange Street. Hay was the petroleum of its time, fueling the draft animals and providing winter fodder for livestock. Farming was the mainstay of the economy until the mid-19th century, when industrialization began. Pictured is Lauren Sawyer's cow, whose farm stood on Pleasant Street in Rockville. (Courtesy of Wayne Simpson.)

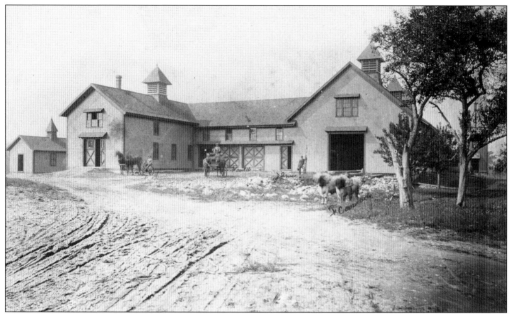

In 1880, Lansing Millis purchased the Wheeler and Lovell Farms along Exchange Street in East Medway. He consolidated them into one farm named Oak Grove. The name came from the grove of oaks growing on the small hill just to the north of the farmhouse. The buildings are reported to have had red roofs. The three-story main barn, which was 140 feet long and 40 feet wide, had two cupolas.

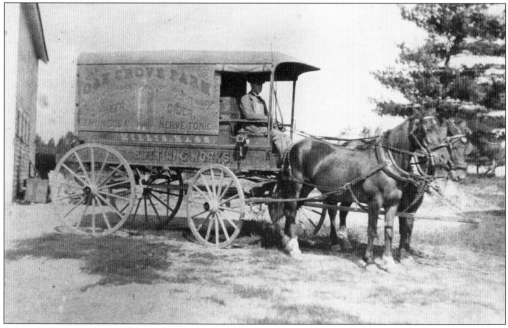

In 1884, Oak Grove Farm began delivering its own milk, which was bottled at the farm in glass bottles. Millis's son Henry and Charles LaCroix also bottled carbonated cider and ginger ale, which were distributed locally by the Oak Grove Farm wagons. This was the beginning of what would become the Clicquot Company.

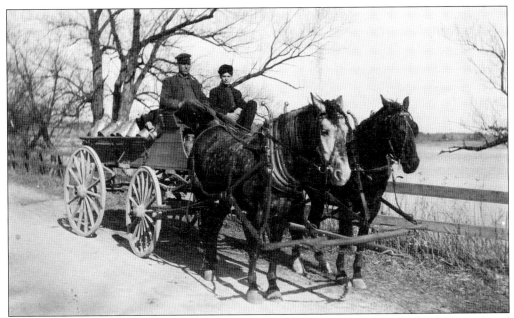

At Oak Grove Farm, a silo was built that held up to 900 tons of cow feed. The farm produced around 1,200 cans of milk each day. Millis hired a farmer from Germany to care for the Holsteins, which were imported from Holland, and the Polled Angus, which were probably imported from Scotland. The farm was reported to be the largest dairy farm in New England in 1890. Shown is a farm wagon with milk cans.

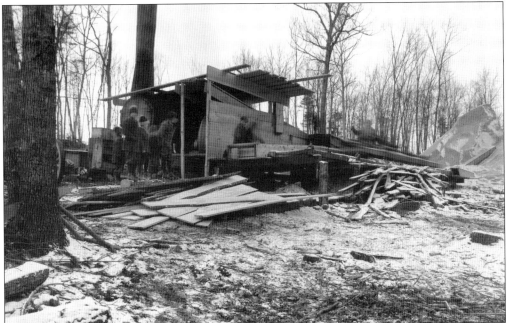

In the winter months, when fieldwork slowed, farmers supplied logs to local sawmills for lumber production. In an 1866 map, sawmills were located on Boggastowe Brook at Ridge Street and Orchard Street and in Rockville. Pictured in 1917 is Richardson's sawmill in Rockville. (Courtesy of Wayne Simpson.)

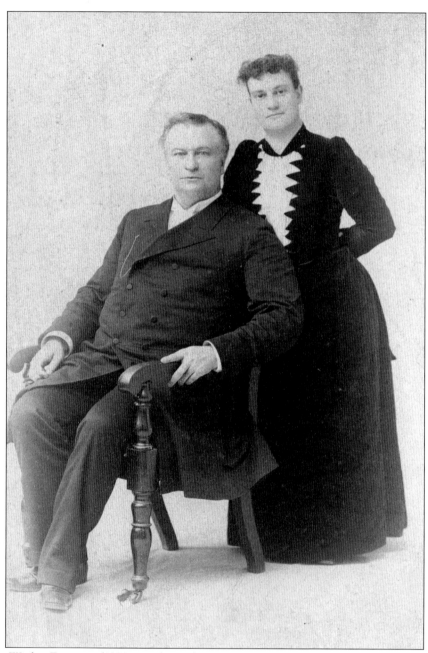

Charles Wesley Emerson (1838–1908) was born in Pittsfield, Vermont, and studied medicine, theology, law, and oratory. He was also on the faculty of the Boston University School of Oratory. Later, Emerson and other associate professors opened their own school of oratory. A noted scholar and educator, he was the founder of the Emerson College of Oratory in Boston, Massachusetts. He retired as president of the conservatory in 1903, and moved to Daniels Street in Millis. He published and distributed textbooks, which he authored, under the name of Emerson Publishing Company. Doctor Emerson was the first chairman of the Millis Board of Water Commissioners. He and his wife, Susie Rogers Emerson, who also was an accomplished public speaker, gave frequent lectures in town. Both Charles and Susie are buried in Prospect Hill Cemetery.

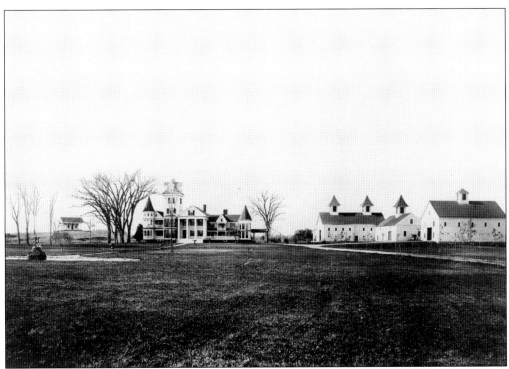

Charles Wesley Emerson and his wife, Susie Roberts Emerson, moved to Millis around 1885 and built Buttercup Farm. The Emersons often entertained faculty and students from Emerson College of Oratory on the farm. Buttercup Farm was located on Ridge Street near the intersection of Curve and Auburn Road. The farm complex no longer exists. (Courtesy of Harold Curran.)

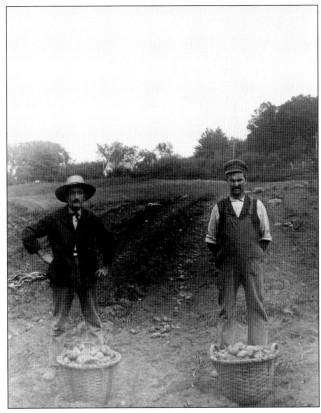

This Walter Prescott photograph was taken on September 24, 1902, of Francis H. Daniels's potato field. His River End Farm stands next to the Myrtle Street Bridge. Daniels was the fifth generation to live on the farm, which was built by Joshua Partridge in 1740. Each basket of potatoes is considered one bushel. (Courtesy of Wayne Simpson.)

Silas Richardson was born on May 9, 1792, and died on April 21, 1889. He was a farmer and a deacon in the Baptist Church in Medfield. In his later years, he attended services at the Church of Christ in Millis, which was within walking distance of his home. Richardson's grandson John S. White of New York presented the town with a tower clock as a memorial to his grandfather. The clock was placed in the Church of Christ steeple.

This house was built by Silas Richardson and originally located on the site of the VanKleek mansion on the corner of Union and Exchange Streets. It was moved to its present-day location on Union Street when Lansing Millis purchased the property to build a house for his daughter Helen, who married Livingston VanKleek.

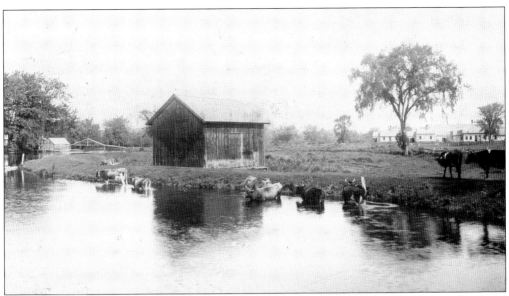

Daniel's Farm, also known as Riverend Farm, is located on Myrtle Street in Rockville at the bridge over the Charles River. In his journal, Walter Prescott writes, "Riverend,—was called this because the farmers, drove their cattle to drink at the river, where the iron bridge now is, it thus being called Riverend." (Courtesy of Hindy Rosenfeld Collection.)

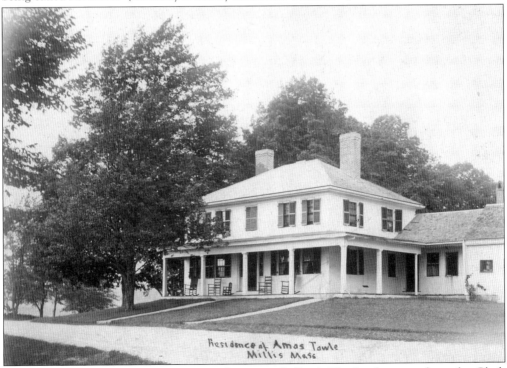

This brick house was built around 1833 by Venus Bullard. The bricks came from the Clark brickyard, located on Causeway Street. The house was purchased by John M. Crane in 1860. For a time, Amos Towle owned the farm, hence the name of Towle's Corner for the intersection of Orchard and Middlesex Streets. (Courtesy of Hindy Rosenfeld Collection.)

Inventor Michael Henry Collins (1822–1891) made his fortune with the invention of a wick system for oil lamps called the Lamp Sun Burner. He also designed a process for the manufacturing of granulated sugar, a quartz-crushing machine, and a building ventilation system. Another invention was the echolin, which was a violin with harmonic strings. His Victorian house still stands on Orchard Street.

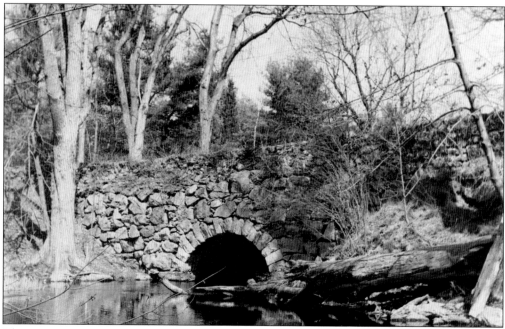

There were at least three stone-arch bridges in the town of Millis. Pictured is the Boggastowe Bridge, located on Orchard Street at Boggastowe Pond near the Millis line and close to Sherborn. A second bridge crossed Boggastowe Brook on Orchard Street to the section of Millis known as the "Neck." This is where the brook forms a large loop as it flows toward South End Pond.

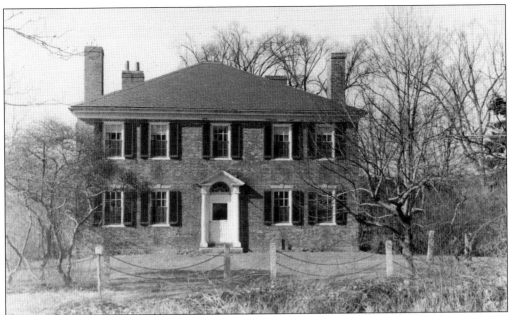

Dr. Abijah Richardson (1752–1822) studied medicine at Harvard College and practiced in his hometown of Medway. When the Revolutionary War started, Dr. Richardson offered his service and was appointed surgeon to the staff of General Washington. He served for four years and after the war built this brick house, which stands on Orchard Street. For many years, he served on the school committee and had an interest in various area mills.

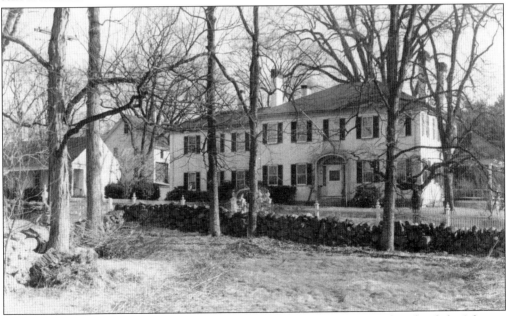

This house, built by Dr. Abijah Richardson Jr., is located across the street from his father's home. It is purported to have been a station on the Underground Railroad prior to the Civil War. Later, Fred Homer Williams owned the home. Williams was the designee who presented the argument to split East Medway from Medway. His son Judge Harold Putnam Williams was an assistant district attorney on the team who prosecuted the Sacco-Venzetti case in the 1920s.

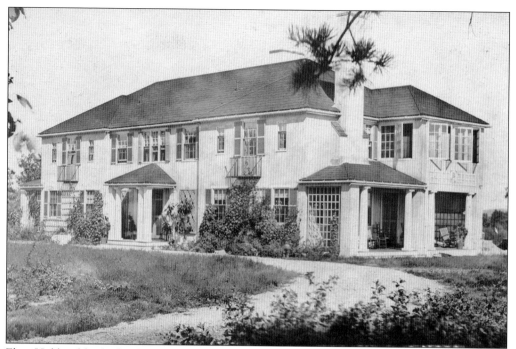

Eliot Hubbard built this house on Orchard Street as a summer residence. Sen. John Kerry (b. 1943) of Massachusetts lived in the house for a time as a child. This c. 1910 photograph is of the pink stucco house.

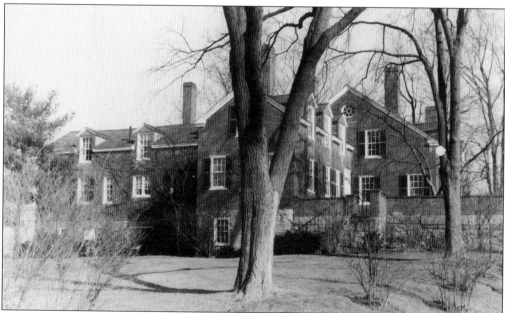

The old Clark property on Causeway Street was settled in 1681. This house was built in 1810, and is a short distance from the original Clark homestead. The property is associated with clay pits and brickyards. This brickyard produced, at times, as many as 500,000 bricks per year. The brickyard closed about 1900. The clay pits were located on Causeway Street and are now small ponds along the road.

Christian A. Herter was born in Paris in 1895. He was a career diplomat, assistant to the secretary of commerce, magazine editor, speaker of the Massachusetts house, Massachusetts congressman, governor of Massachusetts, undersecretary of the state, secretary of state in the Eisenhower administration, and cochairman of the US Citizens Committee on NATO, 1961–1962. Herter died in 1966 and is buried in Prospect Hill Cemetery.

This view of the Clark/Herter farm, or Appleknoll Farm, shows Mary Herter, wife of Christian Herter, on the patio. Farmer Arthur Smith is driving the oxen, and Rudolph "Rudy" King follows the cart. The farm occupies land that was first cleared by John Clark in 1681. From around 1775 until 1900, the family also operated a brickyard there. The Herters purchased the farm in the early 1930s.

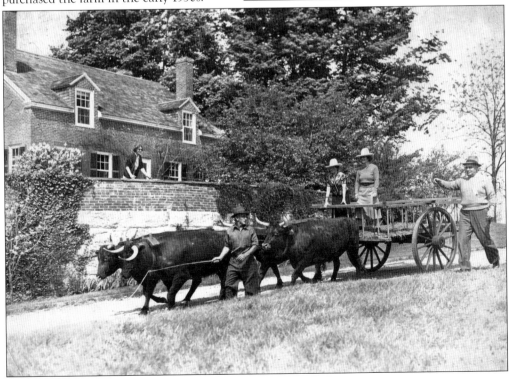

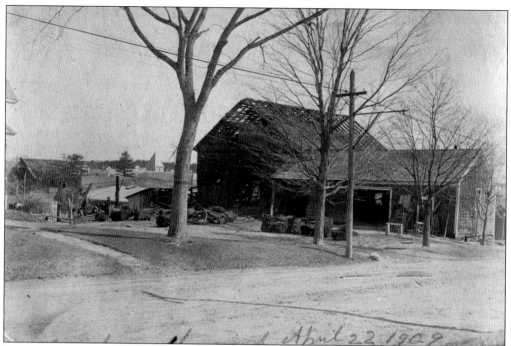

Thorne's barn was located on the north side of Main Street just east of the intersection of Plain (Route 115) and Main Streets (Route 109). The barn burned on April 22, 1909, but was rebuilt. (Courtesy of Harold Curran.)

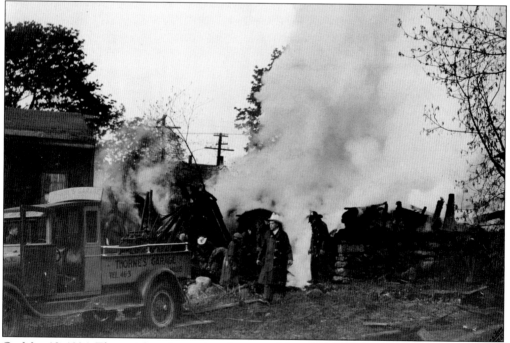

On May 13, 1934, Thorne's barn burned to the ground. In addition to farming, the Thorne family ran a grain, coal, and hardware business in the old opera house on Exchange Street and a Ford dealership across from the barn on Main Street.

Evan Richardson (1867–1951) operated Lowland Farm on Curve Street with his wife, Geneive (d. 1949). He served as treasurer of the town for 30 years and was also a member of the school board. His civic-mindedness prompted him to give the town of Millis 11-and-a-half acres of land in 1932 in order to expand Prospect Hill Cemetery.

Evan Richardson is pictured operating the road grader in Millis. He was a representative in the Massachusetts General Court in 1904 and a county commissioner for Norfolk County for 22 years (1907–1928). From 1928 until 1934, he served as director of the Division of Animal Industry of the Massachusetts Department of Conservation.

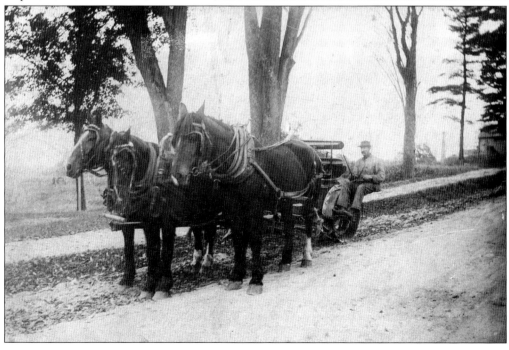

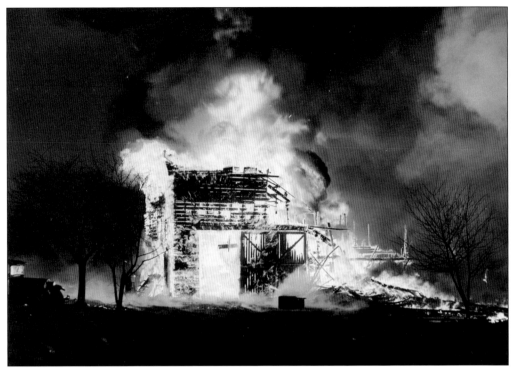

The Winiker brothers' poultry farm was located on Norfolk Road. The above photograph shows a farm henhouse ablaze on March 22, 1937. The lower photograph, post-fire, shows how extensive the Winiker farm operation was at that time. According to the 1945 Millis Assessor's Report, the farm had turkey houses and seven henhouses. After World War II, Ed Winiker ran the farm. As a high school student, he led a dance band, and eventually became a professional musician. He was a poultry farmer and part-time musician until Hurricane Carol destroyed the farm in 1955. Winiker's sons Bo and Bill continue to operate the Winiker Orchestra.

Three

INDUSTRIAL AND
COMMERCIAL MILLIS

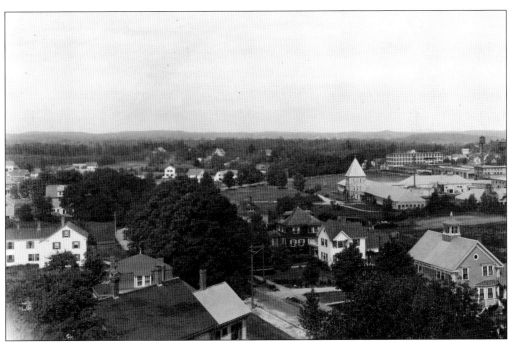

Early industries in Millis consisted of mills, textile and canning operations, brickyards, the organ and clock factory, and the bell foundry. By the 1880s, most of the businesses had closed. With the railroad came larger-scale factories and an influx of workers. A hotel industry began when Jewish farmers started to take in boarders. Pictured are the Steel Edge Factory with its tower, the Clicquot Club, and the Herman Shoe Company.

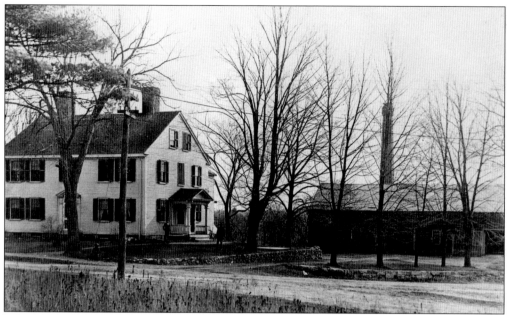

In 1863, James LaCroix started a canning business. Over 150 people were employed in the business, which canned corn, squash, beans, apples, and, in later years, ketchup. He also manufactured refined cider and vinegar. James LaCroix was born in 1823 and died of pneumonia on September 6, 1883. Pictured is the LaCroix House and Cannery, which stood at the corner of Main and Pleasant Streets.

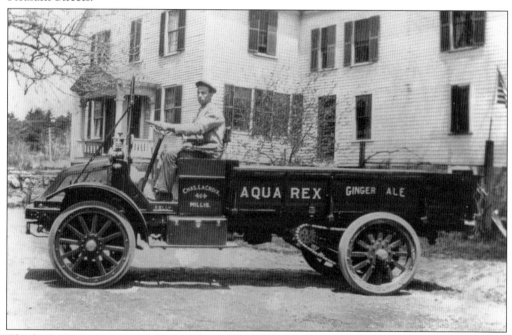

Charles LaCroix was one of the founders of the Millis bottling industry along with Henry Millis. In time, Charles LaCroix established his own bottling company called Aqua Rex. Pictured is Charles's son Millard "Mid" LaCroix in a truck that cost $1,500 and traveled at a speed of 18 miles per hour.

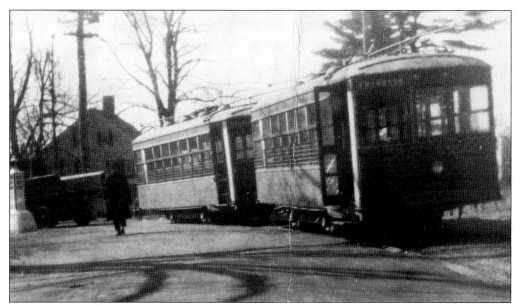

The 1880s saw the widespread electrification of the United States. Advances in electric motor technology led to the development of streetcars, also known as trolleys. Trolley lines were developed within large cities and then spread toward adjacent towns. By the 1950s, most US trolleys were extinct. This trolley, pictured in 1920, is located at the intersection of Pleasant and Main Streets, which is called LaCroix's Corner.

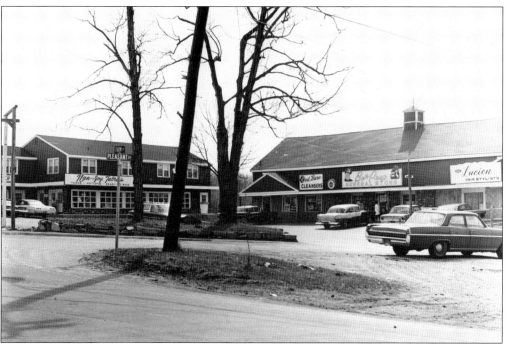

LaCroix's Corner changed radically from the 1920s to the 1960s. From the trolley and the "dummy cops," or the traffic pylon, the street changed to parking lots and stop signs. This photograph shows LaCroix's old cannery building in the 1960s housing Red Barn Cleansers, Bo-Peep General Store, and Lucien Hair Stylists. The building to the left houses a barbershop and fabric store.

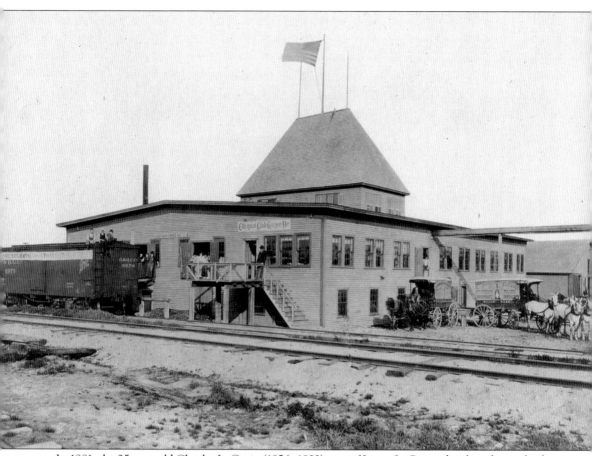

In 1881, the 25-year-old Charles LaCroix (1856–1933), son of James LaCroix, developed a method to carbonate and bottle cider. In 1886, Charles partnered with Henry Millis to form a larger bottling business. They purchased the property at the corner of Union and Curve Streets and named it the Aqua Rex Bottling Works. Henry Millis suggested the name "Clicquot" as a trademark around 1887 after the name of a famous French vintner, because their carbonated cider was much like fine champagne. In order to expand the business, they started to bottle ginger ale, ginger beer, and sarsaparilla, since cider was such a seasonal commodity. Around 1890, the company had outgrown the Curve Street location, so they built a larger facility next to the railroad between Union and Main Streets. This 1892 photograph shows the Clicquot Club plant. (Courtesy of Harold Curran.)

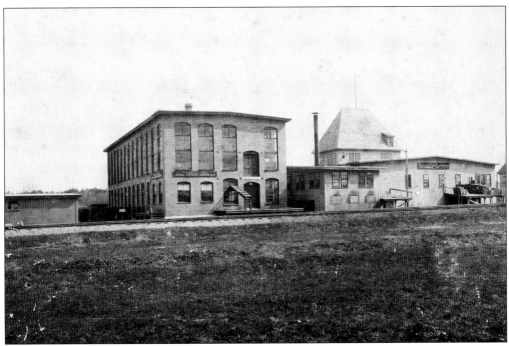

A financial panic struck the United States in 1893 and 1894. Millis and LaCroix suffered considerable financial loss during the crash. Henry Millis was forced to liquidate all of his holdings in Millis, including the Clicquot Club. The controlling interest was acquired by Horace A. Kimball of Rhode Island in 1901. He sent his son H. Earle Kimball to manage the company. Many people remember Earle Kimball being driven in a Rolls Royce daily from his home in Rhode Island to work in Millis. It was the young Kimball who brought widespread success to the company, and he managed it for almost a half-a-century. By 1906, further additions were built, as shown in these two photographs.

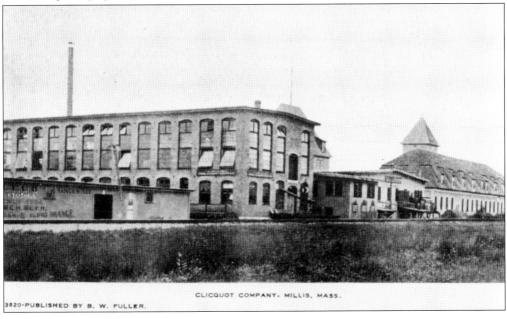

CLICQUOT COMPANY. MILLIS, MASS.

3820-PUBLISHED BY B. W. FULLER.

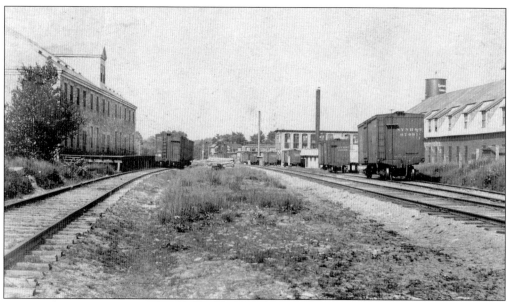

The railroad siding at the Clicquot Club plant was one-third of a mile long. The railroad allowed the company to expand its distribution nationally. At one time, the company's carbonated beverages were being shipped throughout the continental United States and to the orient via steamers. The Clicquot Club rivaled even Coca-Cola and Pepsi products.

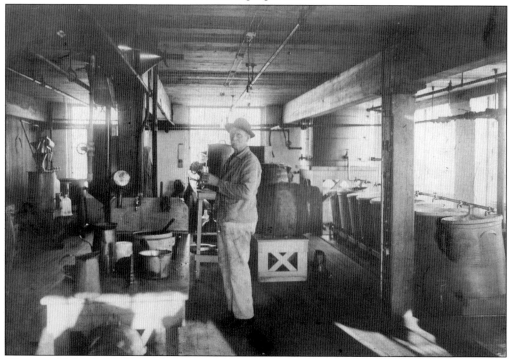

Clicquot Club used only the finest ingredients available on the market for its product. Ginger was imported from Jamaica, and pure cane sugar was imported from Cuba. The water used came from springs located on the property. Pictured in 1904 is the Clicquot mixing room. (Courtesy of Hindy Rosenfeld Collection.)

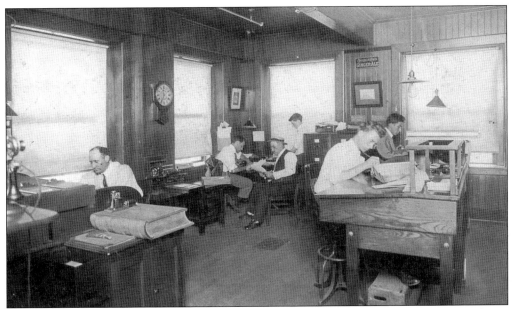

Shown here is the interior of the Clicquot Club office in 1911. Seated and wearing a straw hat is company president H. Earle Kimball. James W. Payson sits at the desk on the left, and Howard A. Payson sits at the front right desk.

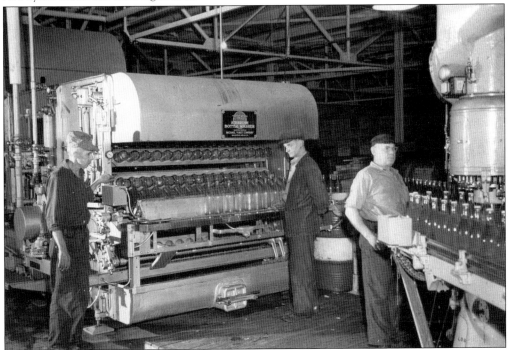

Clean bottles are one of the requirements of the bottling industry. Early on, bottles were hand washed. This 1925 photograph shows a "modern" bottle-washing machine. Manning the machine is James LaCroix (left) and Bill Dorset. The man to the right watching the product line is George Olsen. Older residents of Millis remember hearing the clinking of bottles on the plant's assembly line on summer evenings.

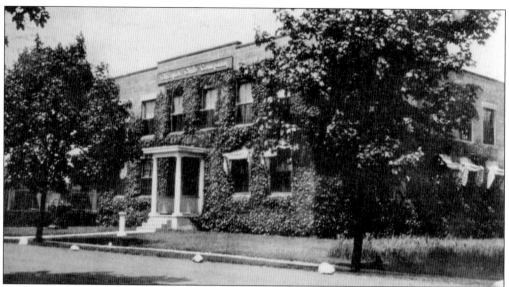

This 1937 photograph shows the Clicquot Club office. In 1938, higher freight rates caused the business to start franchising with local bottlers throughout the country. In time, there were over 100 local bottlers from coast to coast. Also in 1938, Clicquot Club introduced the first nationally distributed soft drink in a can.

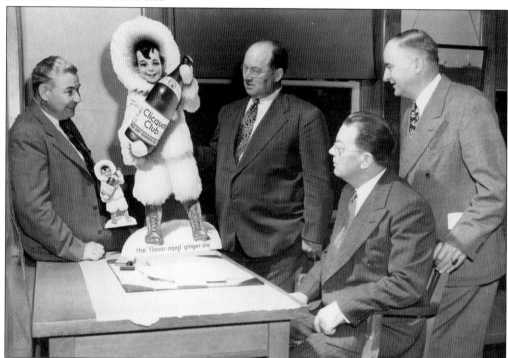

The Clicquot Club was an innovator in advertising. It advertised in newspapers, outdoor billboards, and magazines, including the *Saturday Evening Post*. In 1924, the company installed what was then the world's largest animated electric sign in Times Square, New York. In 1926, Clicquot Club became one of America's first radio sponsors, and it developed the Clicquot Club Eskimos Orchestra, led by Harry Reser. The show remained on NBC radio until 1934.

In 1912, Edward S. Pierce (of Medfield), Clicquot Club's advertising manager, introduced the Clicquot Club Eskimo, Klee-ko. The Eskimo soon symbolized the company, appearing on drinking glasses and reproduced as children's dolls. This photograph shows the Clicquot Club float, which was used in national parades in the early 1950s.

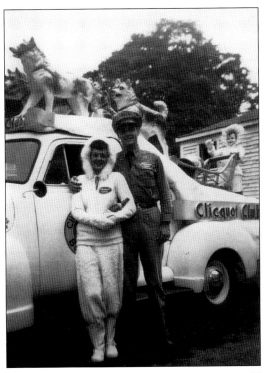

Cott Beverages bought Clicquot Club in 1960. Pictured in the 1960s is the Clicquot yard. By 1980, all production had ceased. According to Charles LaCroix's descendant Paul LaCroix, Clicquot Club is responsible for a number of bottling firsts, such as introducing the first metal bottle cap in 1893, selling the first quart bottles in 1934, and canning the first soft drink in 1938.

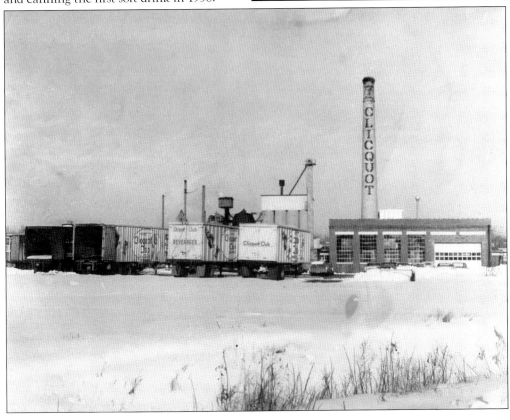

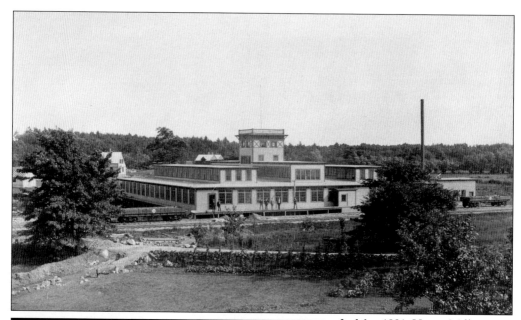

In May 1891, Henry Millis constructed a new factory building for the Frank, Herman & Company. It measured 200 feet by 160 feet. The factory was run under the name of J.W. Thompson & Company, which had moved from Medway, according to the 1891 Massachusetts Bureau of Statistics of Labor. In 1897, it became the Joseph M. Herman Company. Pictured above is the S.W. Thompson Factory, and pictured on the left is Joseph M. Herman, who died in 1920.

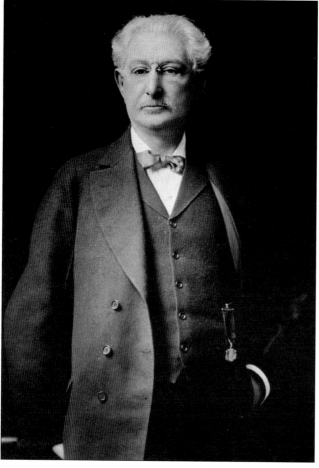

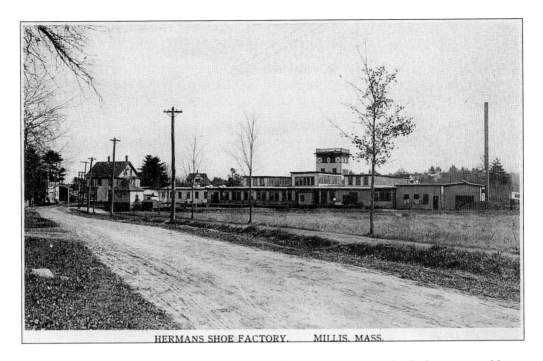

HERMANS SHOE FACTORY. MILLIS. MASS.

The top photograph shows a view of the Herman Shoe Company complex looking east up Union Street. To the immediate left of the factory is the Herman House General Store. According to Evan Richardson in the 50th anniversary pamphlet of Millis, in 1898, the factory received a contract for 35,000 pairs of "army-marching shoes." Pictured below is a close-up of the general hardware store, which was attached to the factory building. Charles Smith owned the hardware store in the 1930s. Smith was also a selectman from 1931 until 1940. People in town remember buying fireworks at the hardware store. (Courtesy of the Hindy Rosenfeld Collection.)

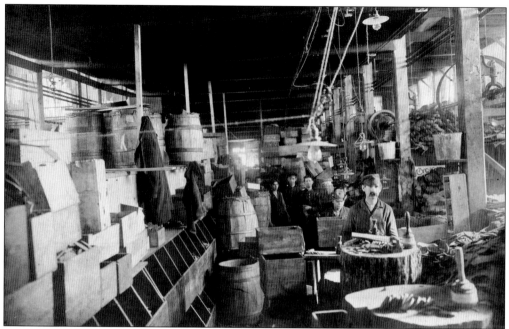

Early shoes were made entirely by hand. Industrial-era workers used machines and performed operations repetitively, accurately, and quickly. Some processes remained handmade, as shown in the photograph above of men with mallets assembling heels. In addition to men's and women's civilian shoes and boots, shoes were also produced for the military from the Spanish-American War through the Korean War. In 1941, the company received a large Navy contract in the amount of $1,092,300, and production was at an all-time high. After the school day, high school students in Millis would work part-time jobs at the shoe factory. Shown below in an undated photograph, the interior of the Herman Shoe Factory can be seen with both men and women sewing shoe uppers.

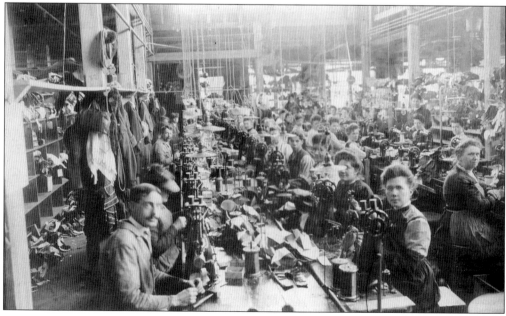

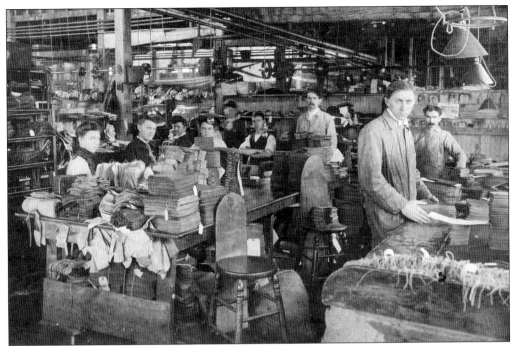

In 1898, the capacity of the factory was approximately 1,000 pairs of shoes per day. By 1913, the capacity was 2,000 pairs per day. During World War I, the company produced shoes for Italy, Russia, and Belgium in addition to the United States. The capacity grew to 4,000 pairs of shoes and boots per day. In 1935, even in the depths of the Great Depression, the factory employed 1,000 workers and produced 8,000 shoes per day. The photograph above shows workers cutting leather shoe parts. The photograph below shows workers in the shop during the final stages of shoe production.

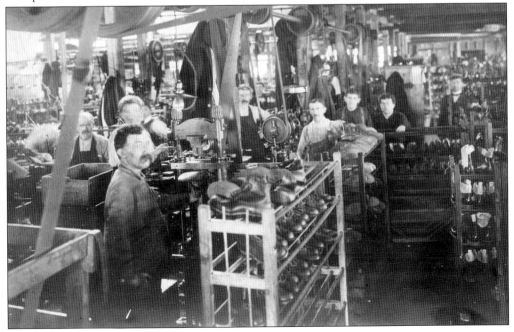

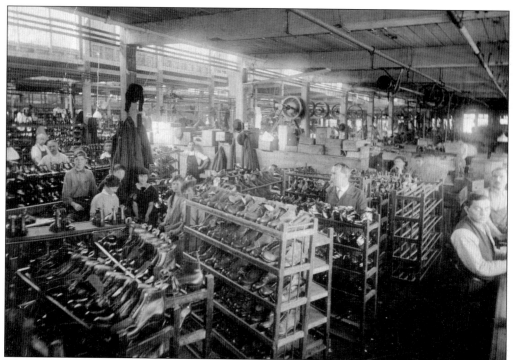

The location of the factory's plant on the railroad line allowed for rapid transportation of both raw materials and the finished product. In addition to government contracts and its own shoe line—including the "Herman Survivors"—the company also produced shoes for Sears and Roebuck, among others. This photograph shows finished footwear being prepared for shipment.

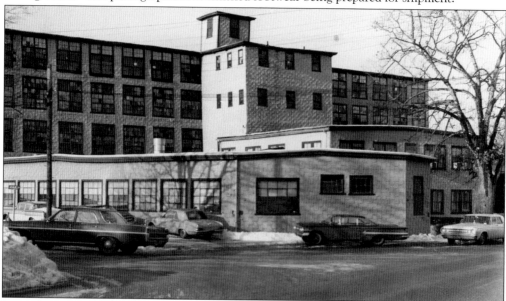

It was during World War I when the upper two stories were added to the building. This photograph shows the factory building in the 1960s. Operations ceased in this building in the late 1970s, when the company was sold to the Stride Rite Corporation. The building then held various small manufacturing businesses until the 2000s.

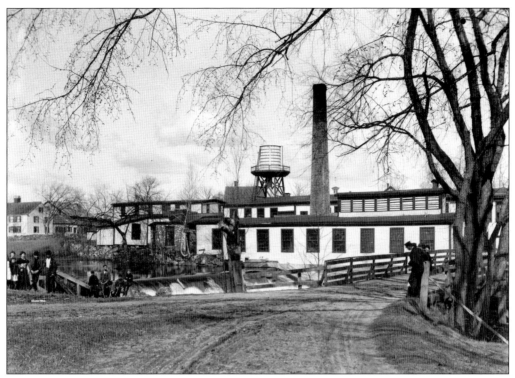

Pictured in 1902 is the Rockville dam and wooden bridge with the mill complex, and to the left (in the distance) is the L. Richardson farmhouse. Walter Prescott's camera was set up on the intersection of Plain, Dean, and Turner Streets. Many mills stood on this site, including the old gristmill. (Courtesy of Wayne Simpson.)

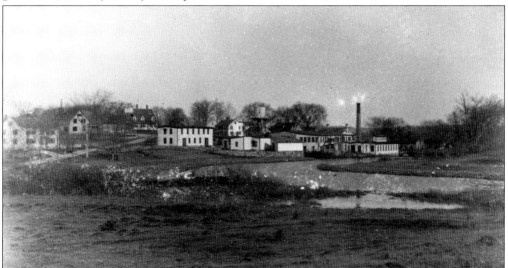

In 1869, W.H. Cary purchased the Rockville Mills that made thread, yarn, sheeting, and cotton cloth. Three years later, the mill was sold to Addison Thayer and Mr. Jenkins. In 1878, Amanda Waite bought the plant for her husband, Enoch. The cotton mills soon eclipsed the gristmill in importance. The buildings burned completely in 1884 but were replaced by the mill complex in this photograph.

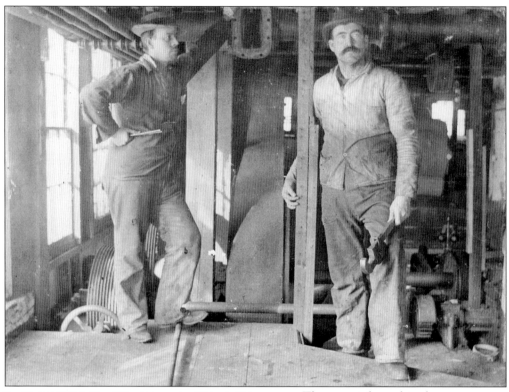

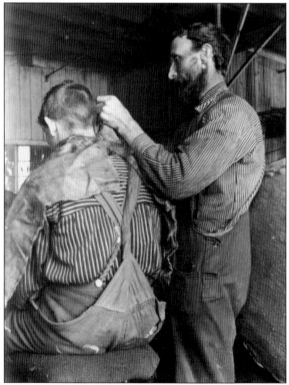

The materials used in the manufacture of felt were extremely combustible, as Walter Metcalf Prescott attested to when he wrote in his journal, "A good, fire trap, these buildings are . . . " After the fire of 1884, Waite's Mill was built with in-house firefighting capabilities. Shown here is a 750-gallon fire pump. The pump operated off the main water wheel, and there was also a water tower, three water hydrants, and a sprinkler system. (Courtesy of Wayne Simpson.)

Herbert Wiggin is shown cutting William Webber's hair in the finishing room of Waite's Mill on April 14, 1900. Herbert Wiggin, according to Walter Prescott's journal, was the "Boss Trimmer" (a mill job title), and was "the real boss of the card room, he rules the former's and cards, puts up mixes (the felt) without necessarily being told what to put in them." (Courtesy of Wayne Simpson.)

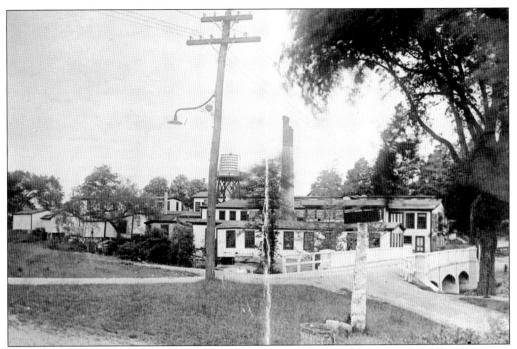

On February 1, 1889, American Felt leased the mill but closed it down in 1911. The American Felt Company of Boston purchased the entire operation from the Waite family in March 1912. Waite's Mill is shown with a new concrete bridge, which replaced the old wooden one.

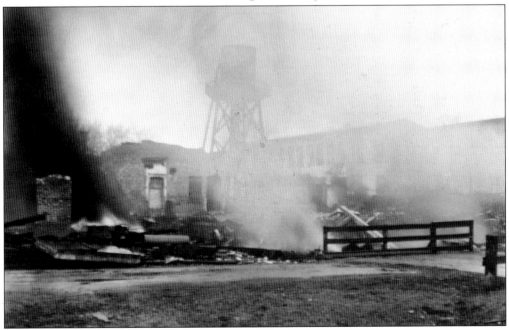

Walter Prescott's photograph shows the felt mill fire on November 22, 1917, at 8:45 a.m. The mill was never rebuilt. In 1920, the buildings, land, and water privileges were sold to the Town of Millis. According to the 1920 Millis Town Report, money was appropriated to purchase the property for a sum of no more than $3,000. (Courtesy of Wayne Simpson.)

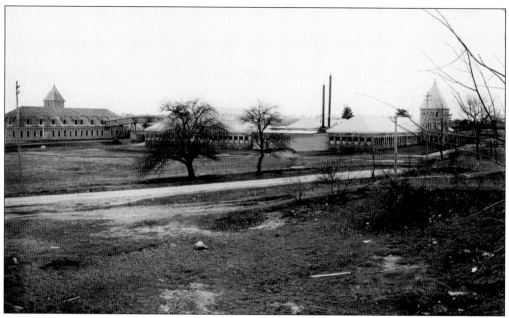

Walter Prescott's 1901 photograph shows the Steel Edge Stamping and Retinning plant. Henry Millis financed these buildings through the Town of Millis. In 1899, the town purchased land that was adjacent to the site for park purposes from Henry Millis for $10,000. Henry agreed to repay the town $1,000 per year for 10 years, in effect donating the land back to the town for financing his buildings.

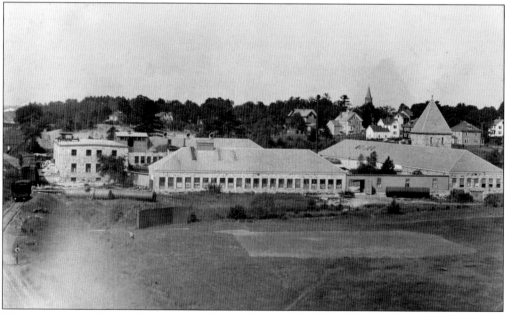

This photograph shows the town park in the foreground with the Steel Edge Stamping and Retinning plant. In 1913, the park was turned over to the railroad and became the Clicquot Railroad Station. The buildings were constructed using local stones, many of which were from Oak Grove Farm stone walls. The factory made stamped tin items. The company changed hands many times until 1913, when the Safepack Paper Mill Company bought it.

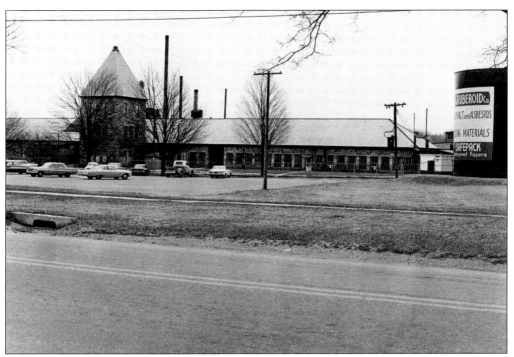

The Safepack Paper Mill Company changed its name to the Safepack Company in 1918. During World War I, the company produced waterproof paper. After the war, production shifted to asphalt shingles. The Ruberoid Company took over Safepack in 1929 and continued with the production of roofing material. In 1967, it was purchased by the GAF Corporation. The GAF Corporation closed the facility in 2009.

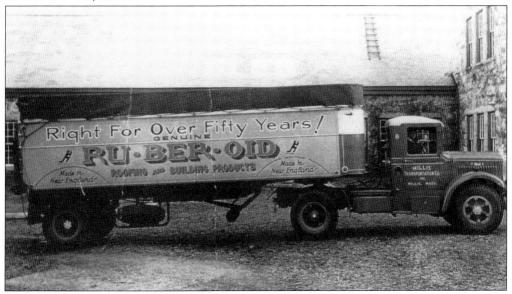

The Millis Transportation Company, Inc., was established in January 1939 by Howard Gould. At that time, the company did contract work for Ruberoid exclusively. The company's garage was located at the corner of Union Street and Railroad Avenue, once known as the Adams Bicknell building. Pictured is a Ruberoid box trailer pulled by a Millis Transportation truck.

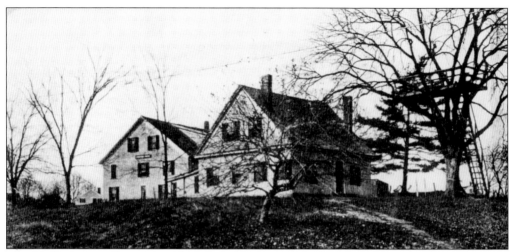

The Stafford House, located on the corner of Union and Curve Streets near the Herman Shoe Company and the Steel Edge Factory, was built in the early 1800s. In 1887, Henry Millis and Charles LaCroix purchased the building to bottle cider. Later on, the building was used for a restaurant and rooming house for local industrial workers. The house is shown in this 1915 photograph.

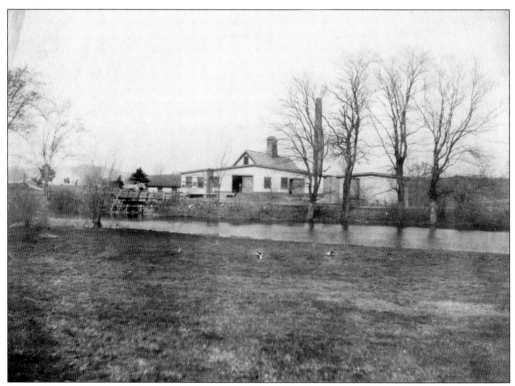

The Baltimore Paper Mill, pictured here in 1899, was located on the corner of Baltimore Street and Norfolk Road (Route 115). This area is also known as the Baltimore neighborhood of Millis. The mill produced rosin paper and roofing paper. (Courtesy of Hindy Rosenfeld Collection.)

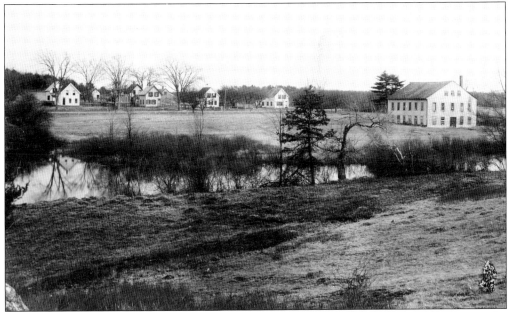

In 1907, the Deanville area of Rockville was named after Dean Walker. The large building to the right is the former third meetinghouse. Dean Walker moved the building without its spire from its original location in Prospect Hill Cemetery to make way for the railroad. It was used in this location for various manufacturing and agricultural purposes. It was torn down by Luigi Brunelli in the late 19th century. (Courtesy of Wayne Simpson.)

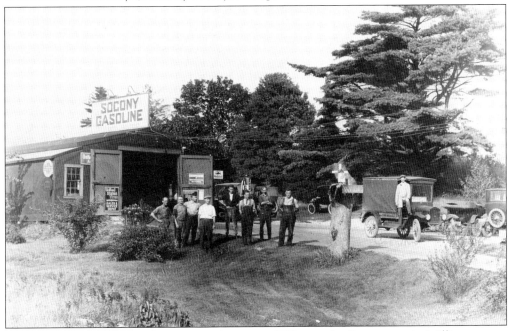

George Holland, who was the town moderator in 1911, was the first person in Millis to own a car in 1904. The first service station was established in 1903 by Adams and Bicknell on Union Street. In the photograph, Del Adams is located fifth from the left. It was one of the first service stations in the area.

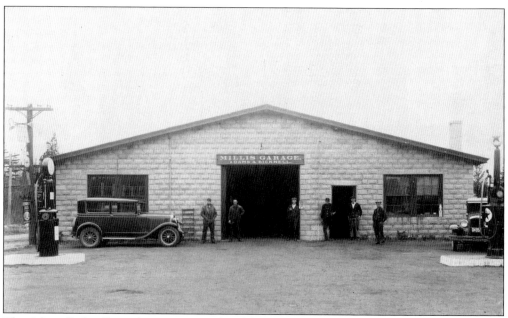

The Adams Bicknell wood garage was replaced by a modern, up-to-date, concrete-block building in 1922. The building later housed the Millis Transportation, Inc. Their trucks carried freight throughout New England, with the exception of Maine. The building is still in use today.

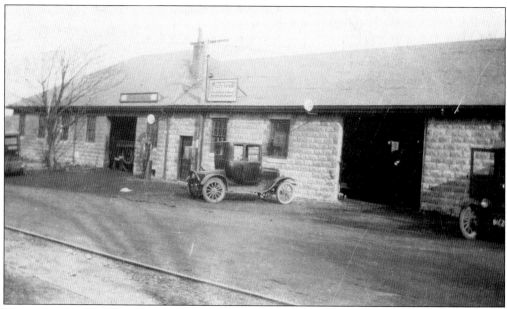

Thorne's garage was located on the southeast corner of Main Street (Route 109) and Plain Street (Route 115). The garage conducted sales and service for Ford cars, trucks, and Fordson tractors. It is currently known as the Maurer Building.

Braman Screw Machine Company was established by Philip Braman in 1952. It was later taken over by his son Robert Braman. The company was typical of small, specialized area manufacturing businesses. The Braman Screw Machine Company closed in 2010.

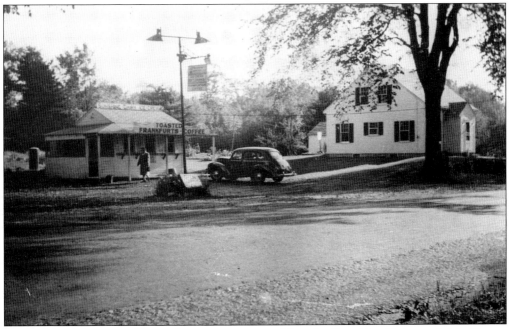

Toasted frankfurters, coffee, and ice cream were sold at the Sunshine Dairy on Main Street, which stood diagonally across from Adam's Street. Edward P. and Katherine Ida Shropshire ran the dairy, and during the winter months, the Shropshires collected seashells in Florida. Upon return, the shells would be sold to customers. (Courtesy of Edward Shropshire.)

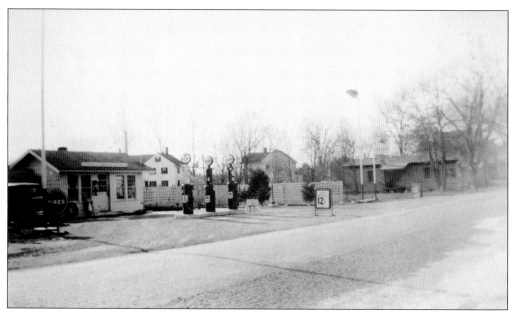

One of the early stations in town, the Harris Gas Station, is pictured with three Sacony gasoline pumps. "Sacony" stood for Standard Oil Company of New York. The price of gas at the time this photograph was taken was 12.5¢ per gallon. The building on its right was LaCroix's Plumbing.

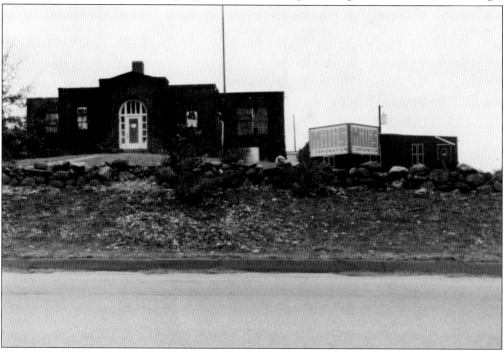

The WBZ transmitting station, located on Dover Road, began operation in March 1931. Millis was chosen for its central location in the area bounded by Boston, Worcester, and Providence. Eventually, the transmitter's signal suffered from the long land path it had to traverse, and WBZ closed the station. The facility moved to Hull, Massachusetts, in 1940. This c. 1960 photograph shows the building, which has since been torn down.

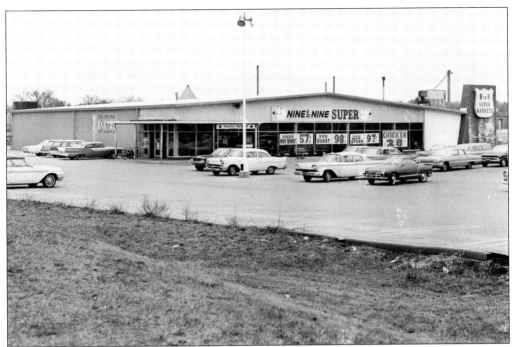

The Nine to Nine grocery store, pictured around the 1960s, was located on Main Street near the Clicquot Company buildings. After it closed, the building housed a Star Market grocery store. The building has housed two hardware stores since the late 1990s.

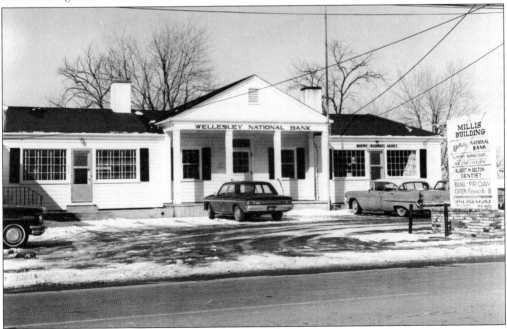

The Millis Building, pictured in the 1960s, was located on Main Street between Auburn Road and Exchange Street. This single-story building was typical landscape of early small strip malls. The buildings have been torn down to make room for Centennial Place, a new mixed-use building that holds businesses and condominiums.

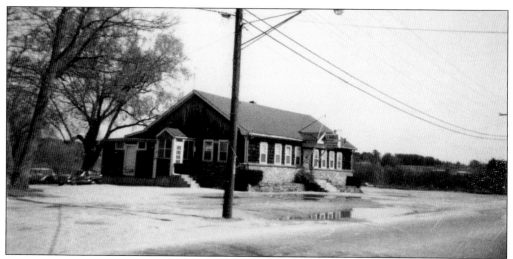

In 1947, three friends purchased a restaurant together on the banks of the Charles River on Main Street (Route 109) on the Medfield line. George "Buckshot" Clancy, Henry McCarthy, and Adam Consoletti opened the Charles Restaurant, also known as Buckshot's. The Clancy family maintained ownership of the restaurant until the early 2000s.

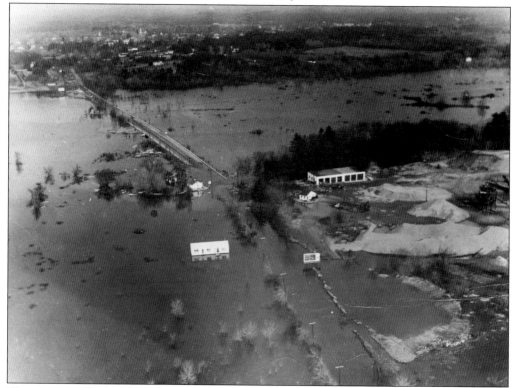

This photograph provides an aerial view of the flood of 1968 at Main Street near the Medfield boarder. The garage-like building on the right-hand side of the photograph shows the Tresca Brothers Sand and Gravel, Inc. Started by immigrant brothers Giovanni and Domenico Tresca in 1920, the operation moved to Millis in the mid-1950s. The small white building located across from Tresca Brothers was Adam Consoletti's package store.

Four

THE JEWISH HOTELS

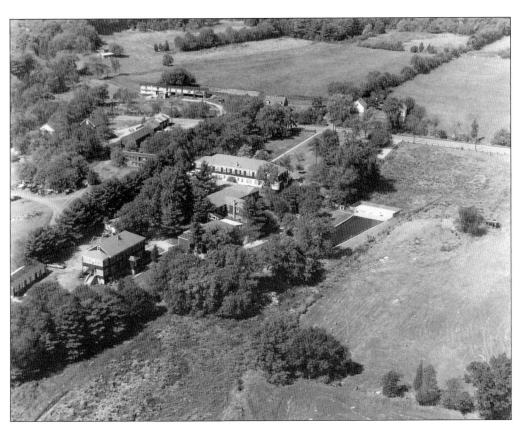

Millis's Jewish farmers started to take in summer boarders to supplement farm income. Arrangements developed over time that eventually turned into a hotel industry. There were seven summer hotels in Millis: Nathanson's Hotel, Novick's Hotel, Cohen's Pleasant Hotel, Carven's Hotel, Rotman's Hotel, Delnick's Indian Rock Hotel, and Winiker's Riverside Hotel. This c. 1948 aerial photograph shows the Novick's Hotel complex on Village Street. (Courtesy of Julius Rosen.)

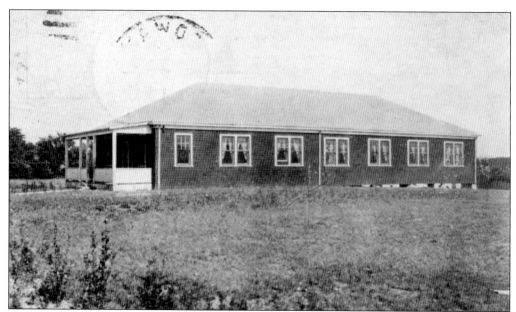

This stamped postcard shows Novick's dining hall. Sam and Rebecca Novick came to Millis and settled on the corner of Acorn and Village Streets. Their hotel featured 84 rooms, including a dining room, a dance hall, and a recreation room. Rebecca was known for her great cooking. According to Julius Rosen, at Novick's the waiters often played musical instruments, becoming the entertainers after dinner. (Courtesy of Hindy Rosenfeld Collection.)

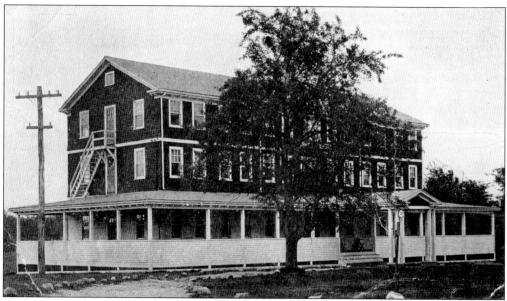

Winiker's Riverside Hotel was located near the Baltimore section of Millis. The hotel, built in 1925, had 50 rooms plus cottages and was adjacent to the Winiker poultry farm. The room rates listed in its brochure were $21 per week for the bungalows and $23 per week for a room in the main lodge. On May 29, 1928, the Riverside Hotel burned. (Courtesy of Hindy Rosenfeld Collection.)

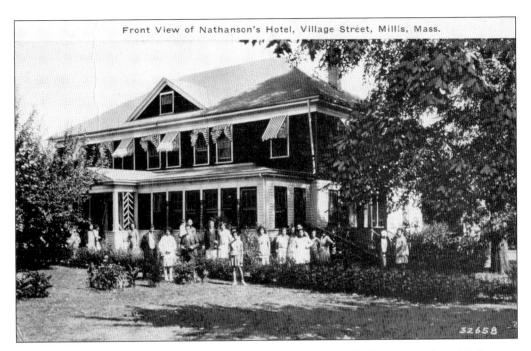

Max and Celia Nathanson established the Nathanson Hotel. In the beginning, Max Nathanson operated the farm and walked two-and-a-half miles to work at the Herman Shoe Company while Celia and the children ran the boardinghouse. The boarders had such a good experience, they wanted to return again, but the owners needed more space. Lands adjacent to the house were purchased, and a 21-room hotel was erected along with a dining hall, a kitchen, and a dance hall. The hotel offered three meals per day, a social director for daytime activities, and evening entertainment. (Courtesy of Julius Rosen.)

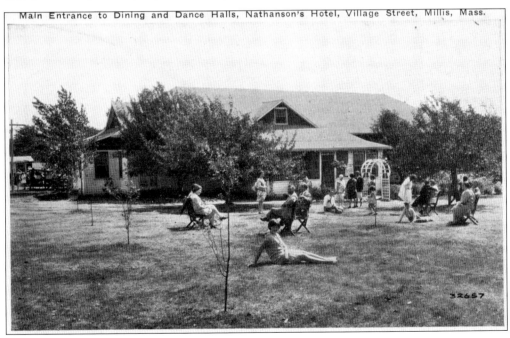

Main Entrance to Dining and Dance Halls, Nathanson's Hotel, Village Street, Millis, Mass.

63

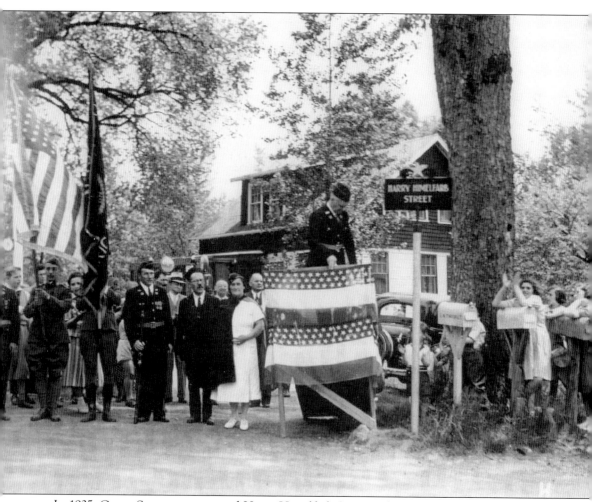

In 1935, Green Street was renamed Harry Himelfarb Street in honor of Harry Himelfarb, who was killed in World War I. Pictured is the dedication being held in front of the hotel. Standing on the podium is Woodrow Rice, and the woman in the white dress is Minnie Winiker. The girls by the mailbox are Florence and Gert Rosen and Francis Simbol. (Courtesy Julius Rosen.)

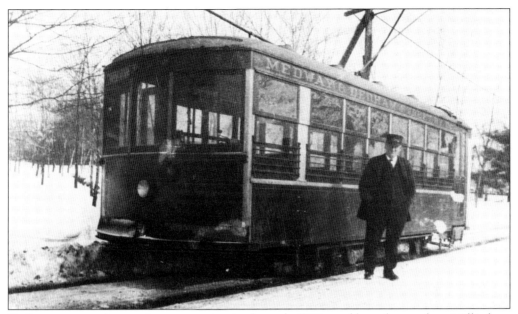

Trolleys were a mainstay of transportation in the early 1900s, and brought people to Millis from Boston and the surrounding areas. In its early years, the Millis hotel industry relied heavily on streetcar transportation. Pictured is the Medway and Dedham Street Railway Trolley with its motorman.

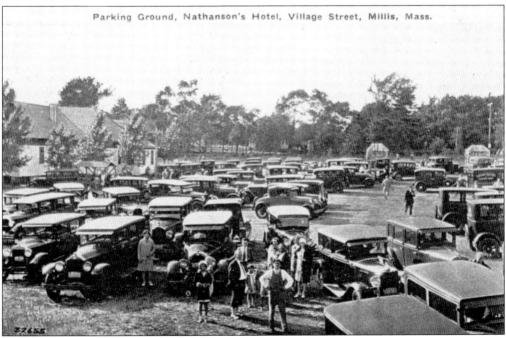

Parking Ground, Nathanson's Hotel, Village Street, Millis, Mass.

Business thrived, as seen by the crush of cars at Nathanson's Hotel. The Millis hotel business continued until World War II, which brought the rationing of gas and food. Guests no longer drove to the country, and hotel owners had difficulty obtaining resources to run their hotels. Many of the summer staff entered the service, and changing postwar lifestyles led to the hotels closing. (Courtesy of Hindy Rosenfeld Collection.)

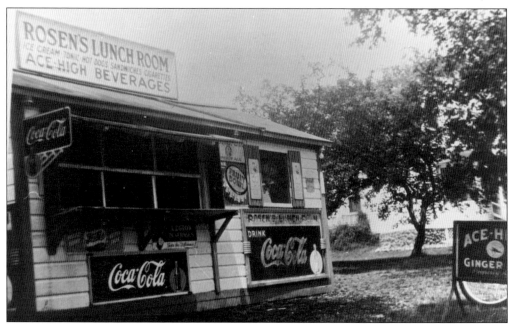

Rosen's Lunch Room was run by Michael Rosen. According to his son Julius, Eddy Winiker delivered the building by truck from Rhode Island in 1938. It was put up in two days on Village Street. Ice cream sold for 5¢ and hot dogs for 10¢. The lunchroom was only open in the summertime and stayed in business until about 1950. (Courtesy of Hindy Rosenfeld Collection.)

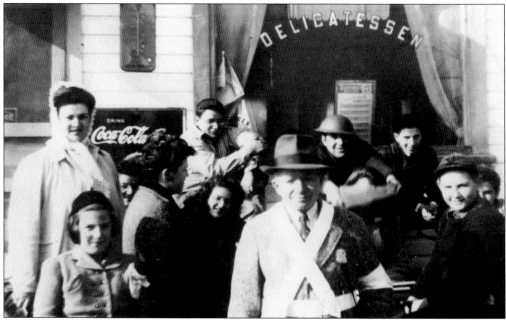

Air raid wardens Joe Novick (in the helmet) and Michael Rosen (in the white belt) are shown in front of Kaufman's Delicatessen during World War II in this 1943 photograph. The deli was located at the corner of Acorn and Village Streets. Standing by the Coca-Cola sign is Seymour Mael. Julius Rosen is to the right of Novick. In the center in the dark coat is Hindy Dazion Rosenfeld. (Courtesy of Hindy Rosenfeld Collection.)

Five

THE FIRE COMPANIES

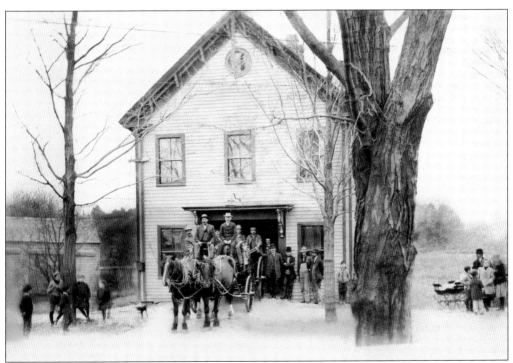

The Niagara Fire Engine Company No. 4, East Medway, was established in 1857. A new building for Niagara No. 4 was completed and occupied in 1879 at a cost of $675. The second-floor interior maintains its original walls with a mural. The mural depicts firefighters battling flames with a view of Niagara Falls. The photograph shows a single front door for access to the horse-drawn pump. (Courtesy of Charles Vecchi.)

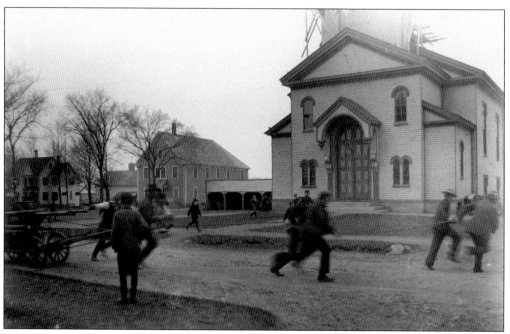

Walter Prescott captured this April 19, 1901, photograph of the Millis Fire Engine Company hand-pulling the Niagara up Exchange Street. The Congregational church's steeple is being repaired in the background. To the left of the church are carriage bays, which were used to protect carriages and horses from inclement weather during services. The Grange Hall is located to the left of the carriage bays. (Courtesy of Wayne Simpson.)

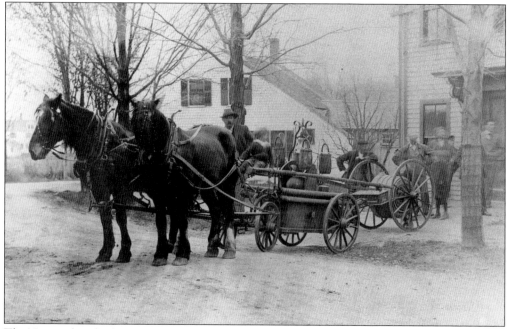

The Niagara hand tub is shown with driver Clarence Thorne in 1905. Hunneman & Company of Roxbury, Massachusetts, manufactured the Niagara in 1857. Notice the leather fire buckets used to help dowse fires hanging from the Niagara and the hose cart located at the rear of the engine.

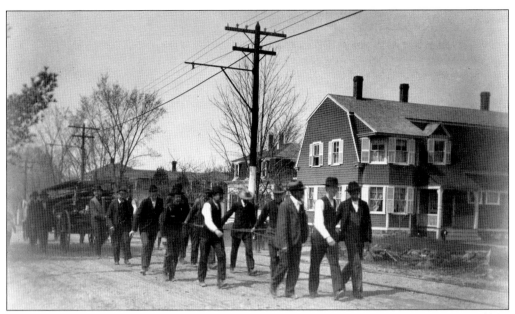

Pictured in 1902 is the Millis Fire Department on parade on Main Street. The engine could be pulled by hand or by a team of horses. The horses were stabled at Thorne's farm at the corner of Main and Plain Streets. When there was a fire, Clarence Thorne would hurry the horses to the Niagara Fire engine house. (Courtesy of Wayne Simpson.)

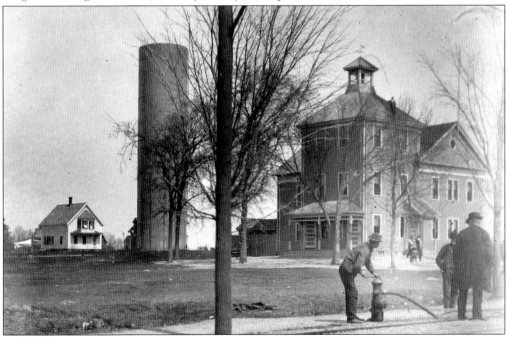

Firemen were captured by Walter Prescott holding a drill on April 19, 1902, at the Adam's School. In 1892, the Millis Water Company built this 80-foot-high standpipe, or water tank. The Town of Millis purchased the water company in 1894 and became the smallest town in the commonwealth to operate its own water department. C.W. Emerson was the first chairman of the board of water commissioners. (Courtesy of Wayne Simpson.)

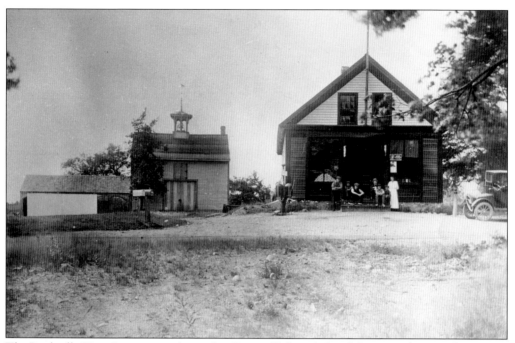

The Rockville Hose 2 engine was housed in Scannell's barn behind the general store. This c. 1920 photograph shows a view of the Rockville general store, the post office, and barn. The post office dates back to 1838. The establishment was the only general merchandise store in the area.

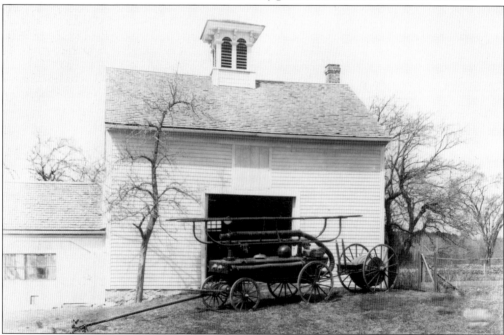

The Rockville Hose 2 hand tub, the Peacock, was purchased in 1887 from Rumsey & Company in Seneca Falls, New York. The engine is of a "squirrel tail" design, because of the way the suction hose curls up and over the body. It was purchased at a cost of $520. The town appropriated $450 to the cost, and the citizens of Rockville contributed $70. (Courtesy of Hindy Rosenfeld Collection.)

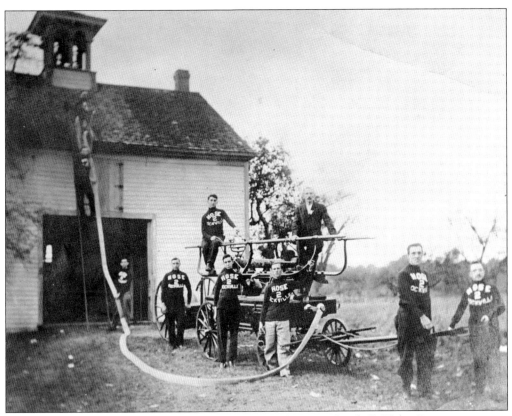

Pictured above is the Rockville Hose Team No. 2 conducting a fire drill. Walter Prescott, wearing a suit, is standing on the engine. The Peacock is pictured below in the barn/firehouse in 1900. The two top bars are called brakes and are in the travel position. When in use, the brakes, or bars, folded down and were pumped by teams of men on both sides. There is a leather seat located on the upper right-hand side where the driver sat while leading the team of horses. (Photograph below courtesy of Wayne Simpson.)

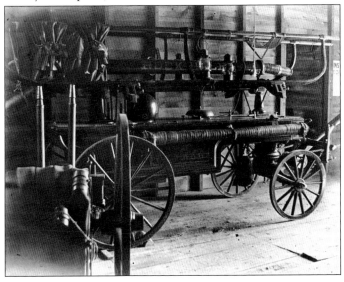

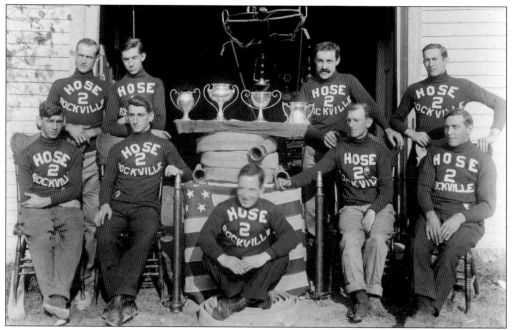

This 1914 photograph depicts the Rockville Hose Coupling Team 2 at the barn displaying their trophies from firemen musters. Companies of firemen would meet and compete against each other to hone firefighting skills. In that year, the company fought four fires in Rockville. It also fought a fire in Norfolk, for which the firemen each received $3. (Courtesy of Wayne Simpson.)

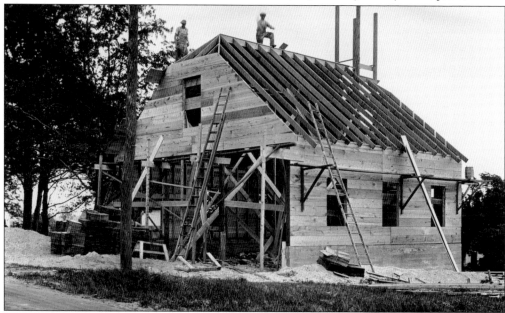

In the 1921 town report, fire engineers Charles LaCroix, J. Clarence Thorne, and John H. Ingraham reported, "Mr. Scannel, owner of the Engine House at Rockville, has raised the rent to $7.00 per month. We recommend that an engine house be built on the Town Park [the Waite's Mill site], a one story building 30 ft. x 30 ft. not to cost over $2,000.00." This June 1924 photograph shows the new Rockville fire station being framed.

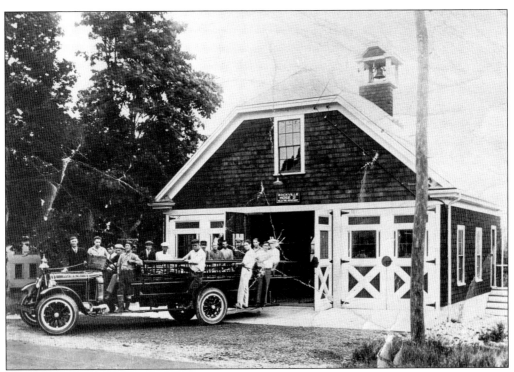

The above photograph shows the completed fire station and the Rockville Hose 2 fire truck with its crew. Below is the Graham Dodge touring car used as a firefighting vehicle complete with bell and fire extinguishers in April 1925. (Courtesy of Wayne Simpson.)

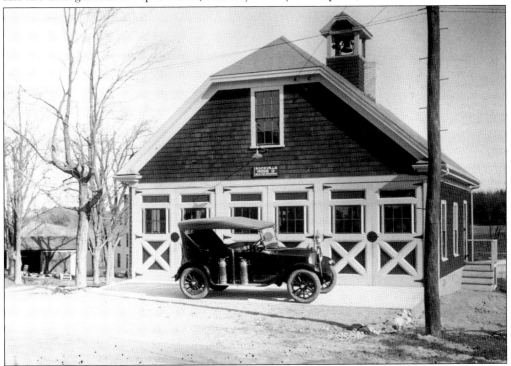

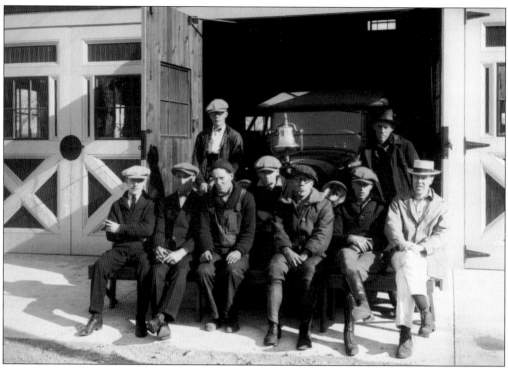

This April 5, 1925, photograph was taken at the Rockville Hose 2 fire station with the Graham Dodge car. Also in 1925, the town purchased a new Graham Bros. combination hose and forest wagon. (Courtesy of Wayne Simpson.)

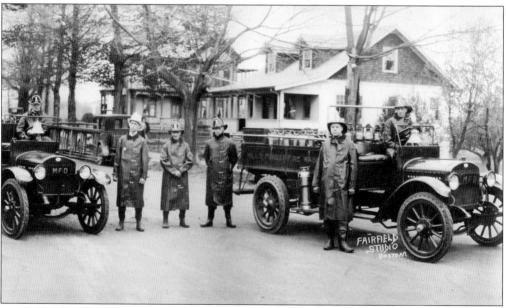

The Millis Fire Department is pictured in 1927 in Holbrook Square with the American Legion Post 208 in the rear. Holbrook Square is located at the intersection of Plain, Exchange, and Curve Streets. Pictured from left to right are Russell Clark, Millard "Mid" LaCroix, Edward LaCroix Sr., Hiram LaCroix, Clark Thorne, and Edward Adams.

On May 13, 1934, the Thorne's barn burned. The Thornes operated the garage across Main Street and stored vehicles in the barn, many of which were lost in the fire. The photograph shows Engine No. 1 on Main Street.

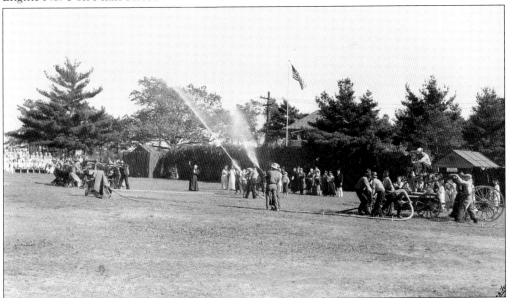

The two Millis hand tubs, pictured in 1935, are performing at the Millis 50th anniversary pageant at the town park. The Peacock is on the right and the Niagara is on the left. Both hand tubs—or engines—have been preserved and are located at the Niagara Fire Engine House.

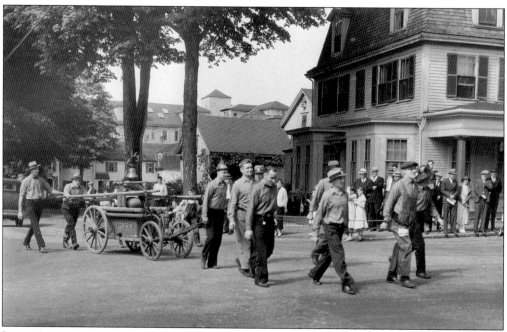

In 1935, according to a report by the fire engineers, there were 87 calls. The worn-out rubber coats were replaced for the Millis Engine Company, and the rubber boots were replaced for the Rockville Hose Company. This September 14, 1935, photograph shows the Millis Fire Department pulling the Niagara hand tub in Medfield's Field Day parade.

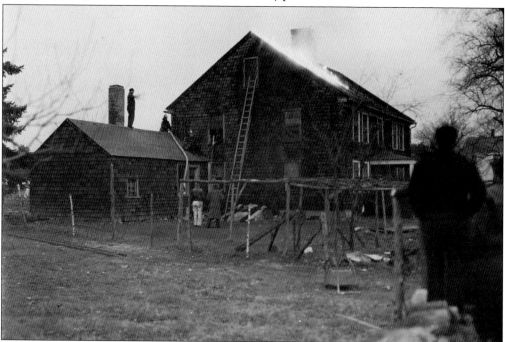

Many of the 1930s photographs of fires were taken by Stanley Chilson to document firefighting in Millis. This December 13, 1935, photograph shows the Mael house roof fire. The Mael house is located on Village Street.

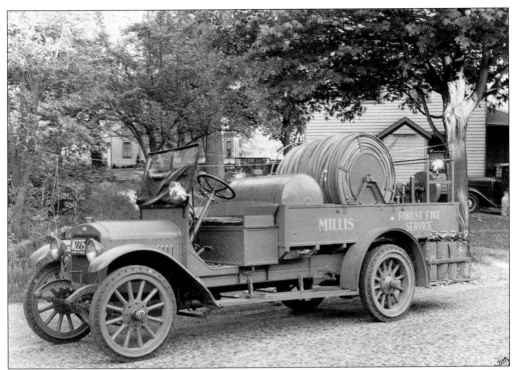

In 1920, there were 27 fires listed in the town report, 17 of them grass or forest fires. In the 1920s, as industry grew and housing developed, better fire equipment was needed. By 1926, there were 52 fires listed in the town report, 15 of them forest fires. One of the fires was a liquor still explosion. Pictured is the Millis Forest Service truck, which was purchased in 1925.

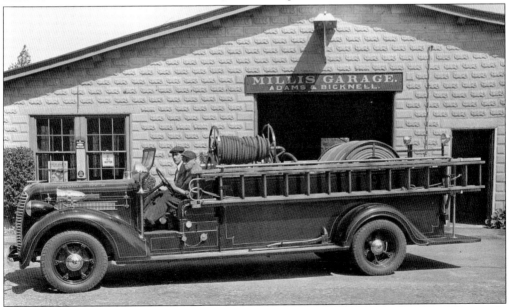

Pictured in front of the Adams Bicknell Millis Garage is the new Diamond T forest fire truck, which was delivered on June 15, 1936. Del Adams was the Millis forest warden and is at the wheel of the new fire truck. In 1936, thirty-five acres of woods burned in Millis.

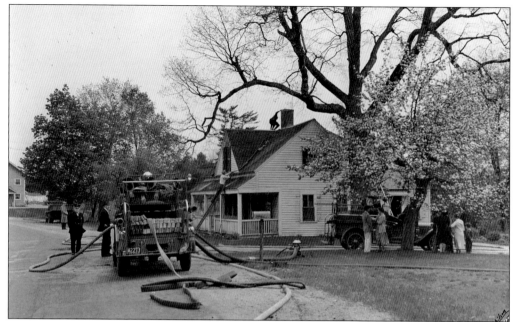

This May 12, 1936, photograph shows the Millis Fire Department fighting the Brodeur house fire. The man in uniform to the left of the fire truck is constable Bill Thorne. The house stands at the intersection of Bridge and Village Streets.

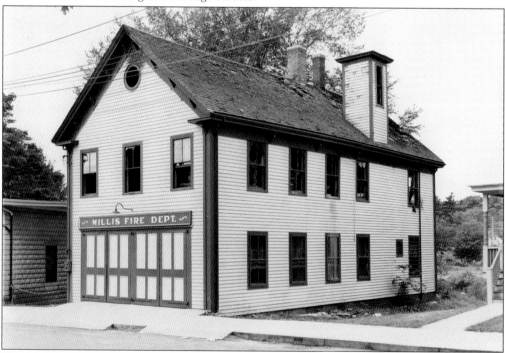

The Niagara Fire Engine House was built of post- and balloon-frame construction. The Millis Fire Department was motorized by 1921. Early-1920s photographs show a change to double doors to accommodate the larger equipment. Fires affected the upper portion of the structure in August 1936, as shown in this photograph, and again in March 1953.

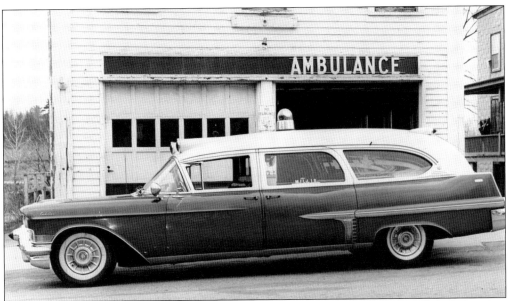

The building was also used to house the town's ambulance. In 1956, the ambulance made its first run. The 1957 town report states, "That the Auxiliary Police Unit and the drivers who operate the ambulance deserve a great deal of credit in giving free time totaling 291 man hours in the operation of the ambulance." Between 1958 and 1970, the building was used for town storage.

In 1978, the town remodeled the building for offices. The replacement of the double door with a window wall was accomplished at that time. These offices moved to the Veteran's Memorial Building in 1997. On July 10, 2001, work was completed restoring the front facade to its original appearance, and the building is now painted in its original colors. (Courtesy of Hindy Rosenfeld Collection.)

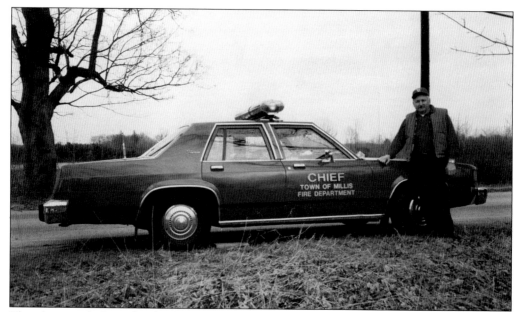

This photograph shows fire chief Robert Volpecelli standing by the fire chief's car. Chief Volpecelli served as fire chief from 1975 until 1995. In 1995, the town appointed him as the first full-time paid member of the fire department. Before this time, all fire personnel were volunteers, and later, call firefighters. The chief's car was a red, repainted, retired police cruiser.

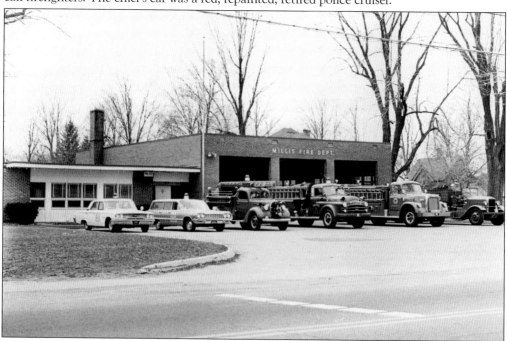

In 1957, the town voted to approve the land on the north side of Main Street, known as the Adams School site, for a new police and fire station. The building was completed in 1958 at a cost of $73,000. From left to right are two police cruisers, a 1938 Ford Fire Engine, a 1952 Dodge Fire Engine, a 1971 International Fire Engine, and the 1927 Maxim Fire Engine, which were used to transport ladders.

Six

SCHOOLS, LIBRARIES, AND PLACES OF WORSHIP

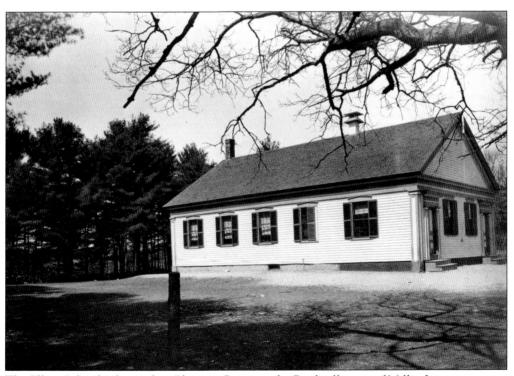

The Ellice School is located on Pleasant Street in the Rockville area of Millis. It is a two-room schoolhouse constructed in 1849. The land was purchased from Seneca and Nancy Barber for $35 by the inhabitants of School District No. 2 in Medway. The Ellice School replaced the 1718 Bent School, so named because it was built where the Charles River bends near present-day Rockville.

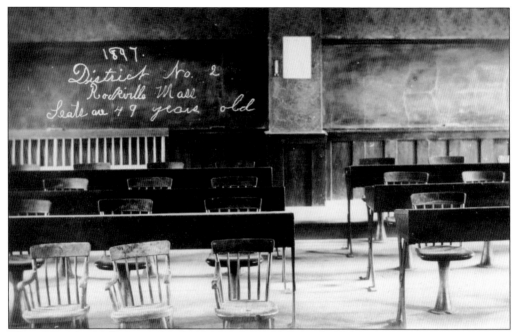

Ellice School, which is now listed in the National Register of Historic Places, was a two-room schoolhouse. One room held grades one through three, and the other room held grades four through seven. The school was heated with a pot-bellied stove, and a bucket of water with a ladle was used drinking purposes. The toilet facility was an outhouse.

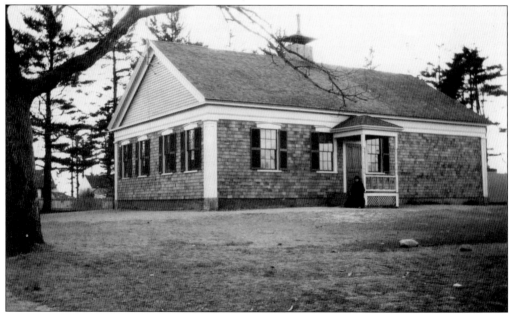

The switch from clapboard siding to shingles is shown in this 1922 photograph. The shingles were laid when the doors were moved from the front to the sides of the building. The building served as a schoolhouse until 1931, when the students were moved to the Adam's School. During the Depression, local women sewed clothing here, and during World War II, women made bandages for the war effort.

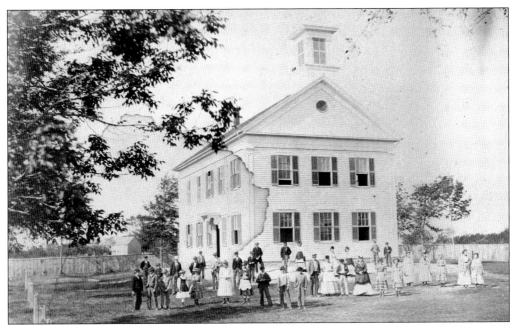

According to E.O. Jameson, the town of Medway decided to build a new school for district No. 1 in East Medway in 1849. This model schoolhouse cost $1,866, including the land and stood where the present police and fire station stands on Main Street. The school was named for Experience Adams, Medway's first teacher, by vote of the town. Shown is an early photograph of the Adam's School.

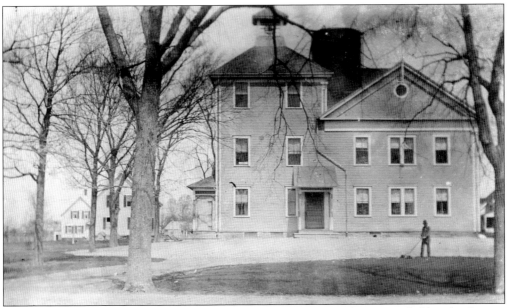

In 1897, conditions in the Adam's School became so crowded that classes were held in the Grange Hall. The school committee recommended that an addition of a three-story, 20-foot-square tower be built on the southwest corner. The cost to build the addition was $4,000. It was built by J.E. Stone of Rockville. Shown in the photograph is the addition to the school. (Courtesy of Harold Curran.)

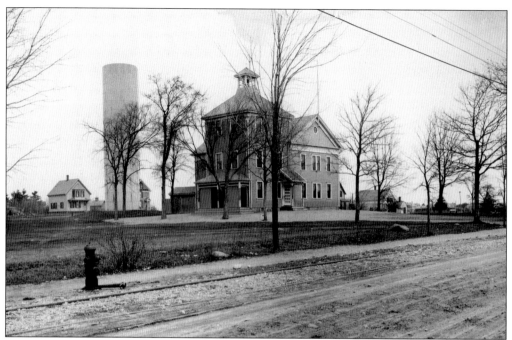

This April 19, 1902, photograph shows the Adams's School on Main Street. In that year, the furniture was scraped and varnished. A new boiler was installed in the building, and an additional radiator was placed in the upper hall. The new heating system meant that children did not have to be sent home because of inadequate heat during the winter months. (Courtesy of Wayne Simpson.)

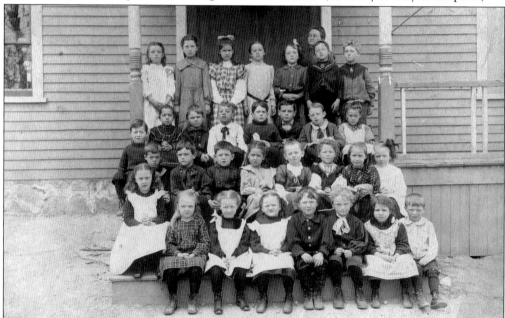

These elementary school children, grades one through three, are pictured on the steps of the Grange Hall in 1898. As stated in the 1890 Millis Town Report, "It is in our public schools that both mental and moral culture are secured, since besides instruction in arithmetic." The teacher was Susie O. Newhouse, and she was paid $352 a year.

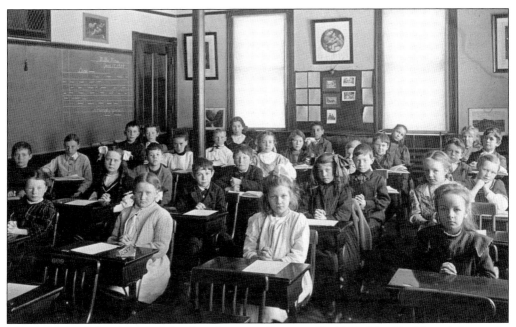

The interior of the Adam's School is shown on January 18, 1909. The blackboard shows the students how to use proper salutations and closings for a letter. Their teacher was Bertha Andrew, and she made $360 a year.

These students, pictured standing on the steps of the Adam's School, include Rudolph King, first on the left in the third row from the bottom. Rudy (1887–1961) served for eight years on the board of selectmen, various town boards, and as town moderator. In 1936, he was elected to the Massachusetts House and served eight years, including speaker in 1943 and 1944. In 1944, Governor Saltonstall appointed him registrar of motor vehicles.

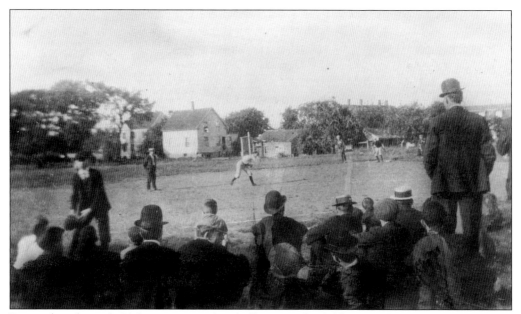

Pictured in the early-20th century is a baseball game. The field was said to be located on Main Street in Millis on the current site of the Veterans Memorial Building. There had been another baseball field on the town park located next to the Steel Edge Factory on Union Street. In 1913, that park was turned over to the railroad company.

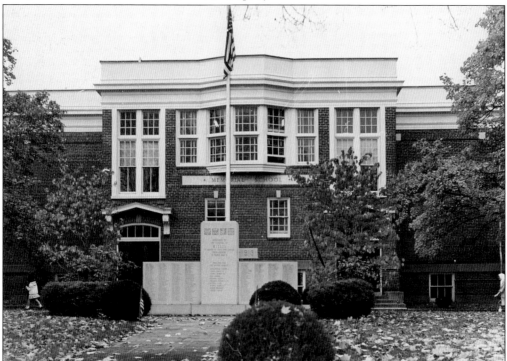

In 1892, the town purchased four acres of land on Main Street from Laura Huntly for $1,600. In 1913, $23,000 was appropriated for the building of a new brick high school. Shown in the photograph is Millis High School with the 1922 additions on either side of the original building.

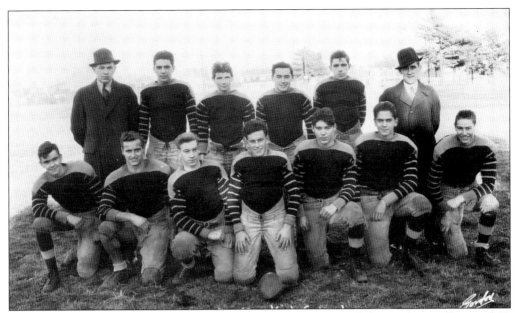

The Millis High School football team is pictured in 1936. From left to right are (first row) E. Cunningham, unidentified, Tim Moran, unidentified, Henry McCarthy, Michael Payson, and John Howie; (second row) Coach McGinnis, P. Duhamel, George "Buckshot" Clancy, team captain Leo McCarthy, Joe English, and athletic director and coach Fred Welch.

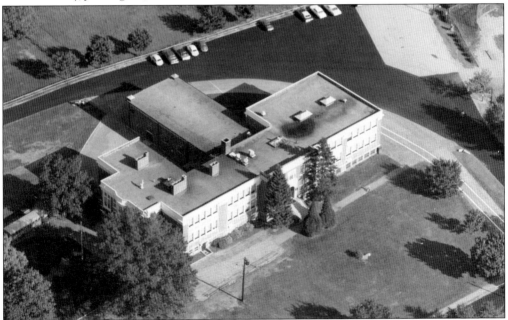

Shown is an aerial view of the Millis Consolidated Schools. In 1931, the town added an auditorium and gymnasium, 12 classrooms, a library, and offices. In the mid-1930s, the neighborhood schools were closed, and all students from kindergarten through 12th grade attended school in the building on Main Street. At a special town meeting on October 14, 1958, monies were appropriated for a new junior and senior high school building. The old school building is currently used by the community and for town offices.

Clyde F. Brown was hired as the principal of the Millis Schools, and he served in that capacity for 35 years. Millis's only elementary school was named in honor of him. In 1953, the cornerstone was laid with messages inside from Pres. Dwight D. Eisenhower and the governor of the commonwealth at the time, Christian A. Herter.

Pictured is the Clyde Brown School. The school opened in December 1954, but increased enrollment called for more space. In 1989, ground was broken for a new addition to the Clyde Brown School at a cost of $4,247,200. Construction was completed in November 1990. At this time, all elementary students who were using Memorial School moved to the Clyde Brown School, and the Memorial School was closed.

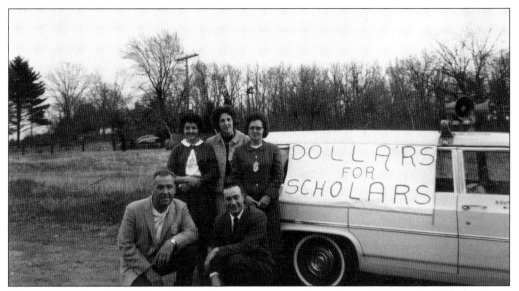

The community of Millis has always been generous to its students. "Dollars for Scholars" was used for scholarships for the graduating seniors. Included in this 1963 photograph are Hindy Rosenfeld (top row center) and principal William Vellante kneeling on the right. (Courtesy of Hindy Rosenfeld Collection.)

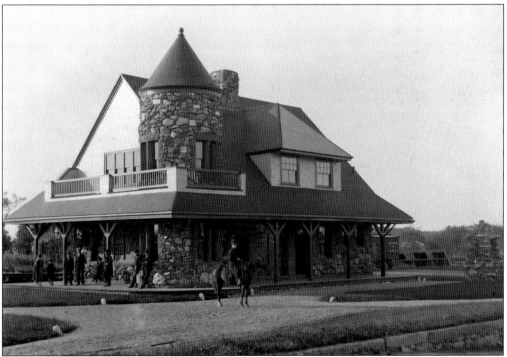

In 1885, the Lansing Millis Memorial Building was constructed as a railroad station, town offices, and town library. The stone structure has a steeply pitched roof with a wide overhang, which creates a walkway around the building. Trim including cornerstones, arches, and horizontal banding are brownstone. Inscribed on the brownstone band is "W.14.8 m B.22.7 m," to indicate the number of miles from the Millis station to Worcester and Boston, respectively.

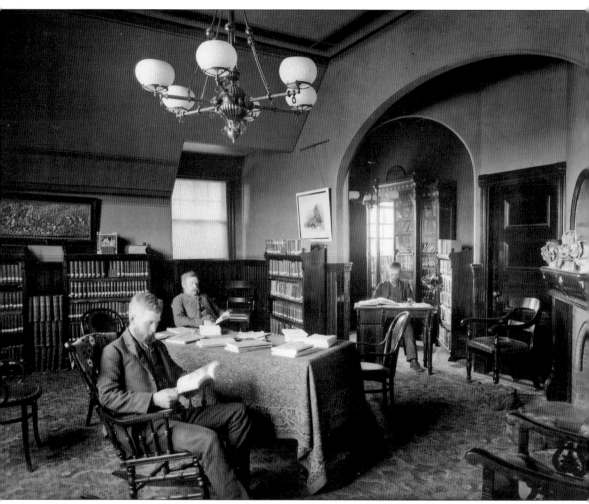

A library was established in East Medway in 1878, and members of the library society paid dues for the use of it. In 1885, when Millis was incorporated, the library society donated its books and funds for the Millis Free Public Library. A dog tax was levied in 1885 to fund books for the library. This photograph shows the interior of the first Millis Free Public Library. On January 1, 1887, the library was opened to the public. The 1888 town record reports the total number of volumes at the end of the year was 1,025. The library remained in the Millis Memorial Building until May 1964, when it was discovered that termite damage had made the building unsuitable to support the 12,000 volumes of books on the second floor; the building was closed immediately. Volunteers and the department of public works moved the books to the new, temporary library, which was located in the brick stores on Exchange Street.

Pictured is the new library building, which opened on February 20, 1967. It is located on Main and Auburn Streets. The mezzanine was added in 1978, and Dora's Reading Room was added in 1993. In the 2000s, it was determined by the trustees that the 5,400-square-foot building was inadequate, both in size and condition, to effectively serve the community. On May 11, 2010, the Town of Millis voted to approve construction monies for a new library.

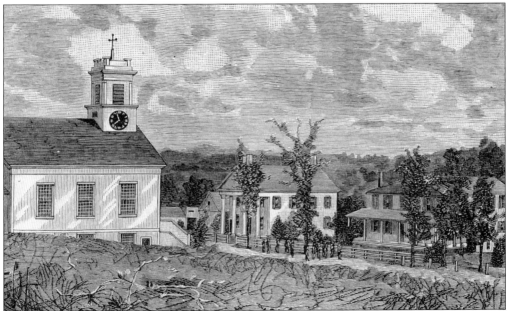

In 1865, the Episcopalians took over this Methodist church, located on Main Street on the south side of Bare Hill near the third meetinghouse. An Episcopal seminary was established in the columned building, located to the right of the church in this etching. The rectory is the building on the right. Both church and seminary burned entirely on February 5, 1871. The rectory burned a few months later.

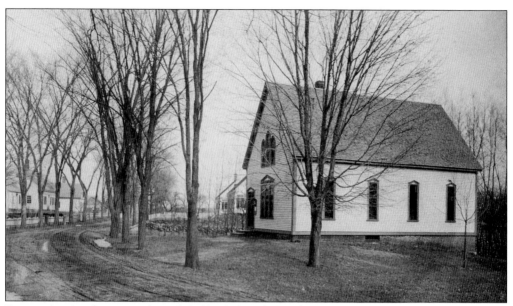

For many years, there was a branch Sabbath (Sunday) School in Rockville connected to the First Church of Christ. In 1874, the residents of the area started Rockville Improvement Association to raise funds for a school that would also be used for social gatherings and religious meetings. The Rockville Chapel was built at a cost of $1,604, and it was dedicated on July 26, 1877. (Courtesy of Hindy Rosenfeld Collection.)

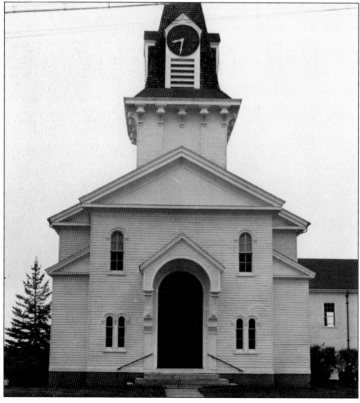

The fourth meetinghouse was erected and dedicated in 1850 on lands given by Joseph Richardson. The church stands on Exchange Street near Curve Street. The First Parish Congregational Church is now known as the Church of Christ. In 1854, a Holbrook organ was installed, and a Holbrook bell hung in the bell tower. The Ladies Aid Society paid for a new steeple in 1900.

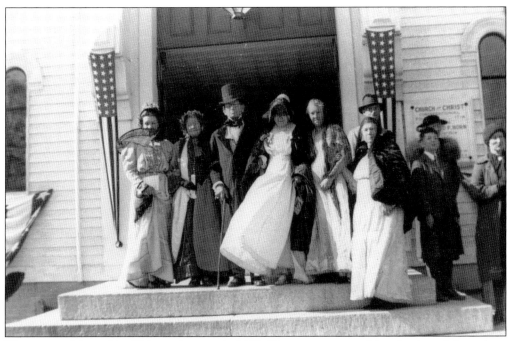

The town celebrated its 50th anniversary in 1935. The anniversary celebration lasted three days, from May 30, 1935, through June 1, 1935. Included were a parade, fireworks, a band concert, and a historic pageant performed twice. The pageant consisted of nine scenes, or episodes. The townspeople portrayed historical characters from Millis history. The photograph depicts participants dressed in historical costumes standing on the steps of the Church of Christ.

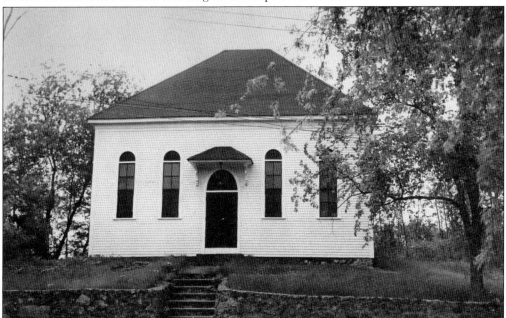

The president and founder of the first Jewish synagogue, the Temple House of Jacob, was Joshua Mael. The temple was built in 1910 on Village Street and served its community until closing in 1975. The building still stands, but it is now used as a private residence.

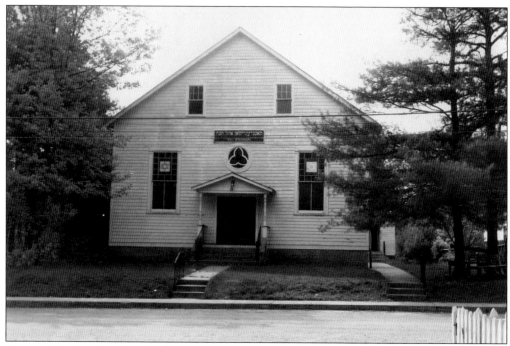

A second house of worship for the Jewish community was initiated with the donation of land, also on Village Street, from Max and Celia Nathanson. The synagogue was named AEL Chunon. The Commonwealth of Massachusetts granted the synagogue corporation papers on May 7, 1928.

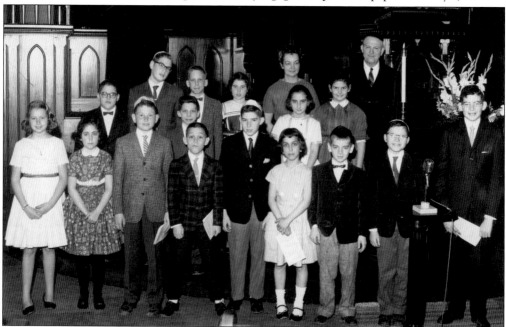

Shown in this photograph is a group of children at a synagogue. In the first row, third from the left, is Joel Rosenfeld, who was later a Millis policeman, local farmer, and businessman. Next to Joel is musician Bo Winiker, who, with his brother Bill, took over the Winiker Orchestra from their father, Ed.

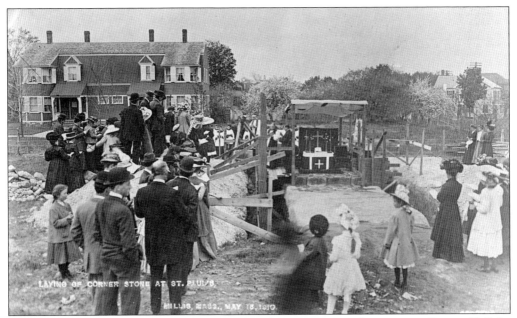

In 1907, Reverend Miner of Franklin started performing Episcopal services at Grange Hall. In 1909, land was purchased from Dr. Emerson on Main Street for the building of a permanent church. The laying of the cornerstone for St. Paul's Episcopal Church is pictured on May 15, 1910. Designed by George L. Smith, the building was constructed in the Arts and Crafts style. (Courtesy of Hindy Rosenfeld Collection.)

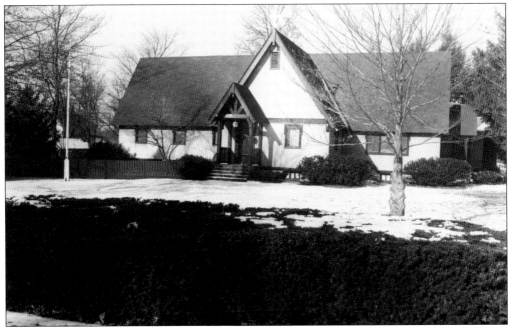

The first service for St. Paul's Episcopal Church was held in the basement on September 22, 1912. In the early 1950s, a parish house was built to provide Sunday school rooms and meeting space. A parish hall was built in the 1970s. The church closed its doors in 2010. (Courtesy of Hindy Rosenfeld Collection.)

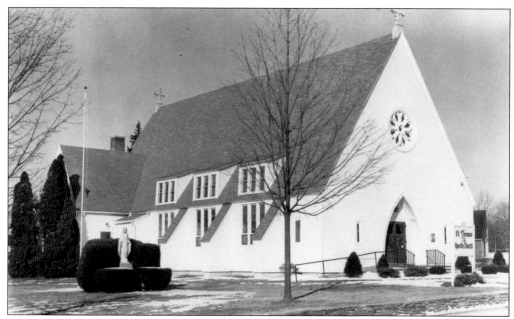

In the early years of the 20th century, Millis saw an influx of workers who were employed in the expanded factories, and many of them were Catholic. In 1937, the Catholics built St. Thomas the Apostle Church on Exchange Street. The first Sunday service was held on February 14, 1937. The Neo-Gothic Revival building has a steeply pitched roof and a rosette window in the gable peak. (Courtesy of Hindy Rosenfeld Collection.)

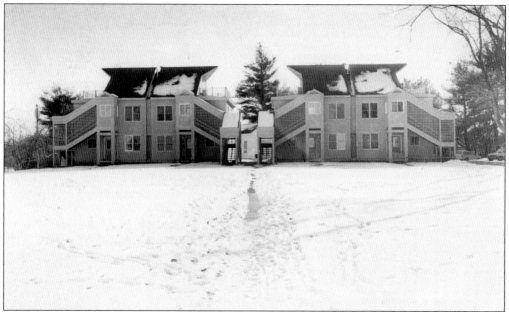

The Guru Ram Das Ashram and Gurdwara was established in Boston in 1970 and moved to the former Novick Hotel on Village Street in 1981. The Sikhs were renovating the building when, just before its completion in May 1982, the central portion of the building was destroyed by fire. A second design was developed for the community, and the structure was rebuilt. (Courtesy of Hindy Rosenfeld Collection.)

Seven

ROCKVILLE

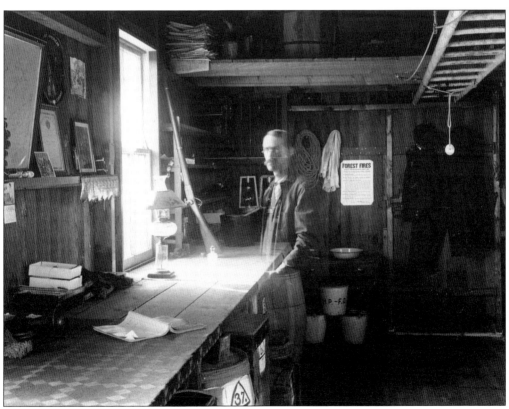

Walter Prescott was born in the River End district of Norfolk in 1871. He worked in the felt mill, was a photographer, volunteer fireman, and chronicler of daily life in Millis. His photographs, taken mainly between 1899 and 1926, are an important photographic record of the town. This photograph, from a glass-plate negative, is a self-portrait of Walter in his Deanville house in 1912. (Courtesy of Wayne Simpson.)

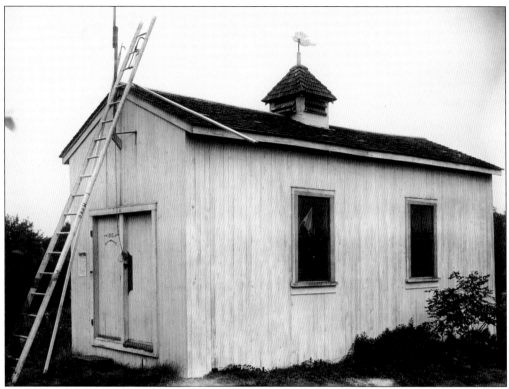

Walter Prescott called this small building his "Deanville House." Deanville is the section of Millis across the Charles River from the Rockville section. Deanville got its name from Dean Walker, a prominent Rockville mill owner. After Prescott's death in the 1950s, Raymond Simpson acquired the building and recovered many of Prescott's glass-plate negatives and private journal. (Courtesy of Wayne Simpson.)

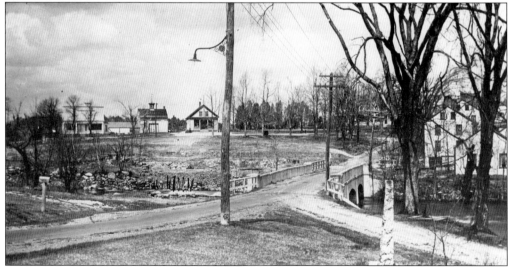

By 1917, when this photograph was taken, the felt mill was gone. The wooden Pleasant Street Bridge had been replaced by a concrete structure. There are power lines running up Dean and Pleasant Streets, but the roads are still gravel. Turner Street is on the right.

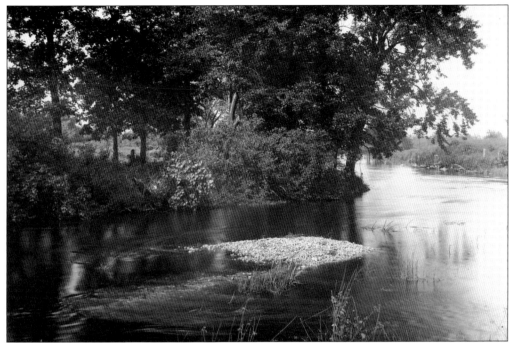

This 1923 photograph by Walter Prescott shows the river near the Myrtle Street Bridge. This is the area where early settlers forded the river, thus becoming known as River End. (Courtesy of Wayne Simpson.)

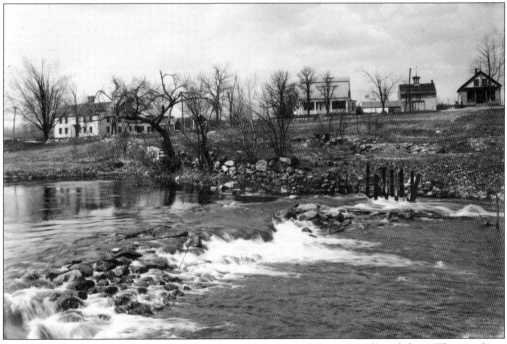

This 1923 photograph of Myrtle Street shows the ruins of Waite's Mill and dam. This is where the Rockville Fire Station and Waite's Park now stand. On the left is the Richardson Farm. On the right is the barn that was used to house Rockville Hose 2 and the Rockville store.

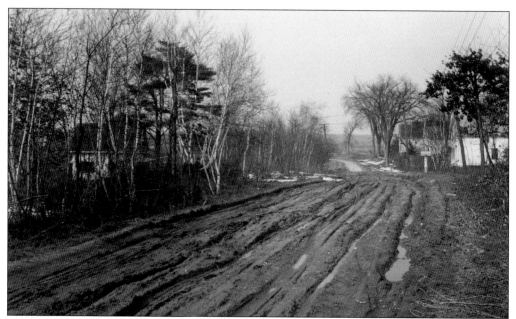

Before the widespread use of oil-based paving, early spring in New England was "mud season." Thawing gravel roads turned into quagmires. Prescott took this photograph on April 4, 1924, near the Norfolk town line. The introduction of Tarvia, macadam, and other asphalt products effectively ended mud season in Southern New England. Residents now suffer "pothole season." (Courtesy of Wayne Simpson.)

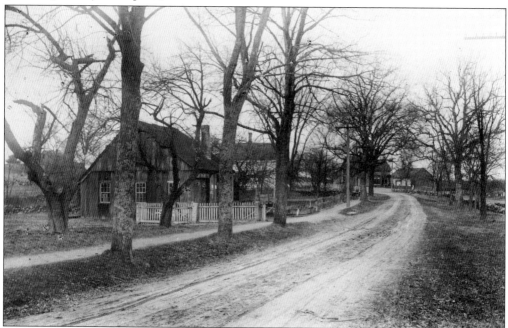

Edwin T. Rogers was the village blacksmith in Rockville. According to Walter Prescott, he was known as "the Rockville newspaper" or "the town crier." One year, a shoe tongue was hung on the Rockville Chapel Christmas tree to poke fun of his gossipy nature. Shown is a 1907 photograph of Rogers's blacksmith shop. (Courtesy of Wayne Simpson.)

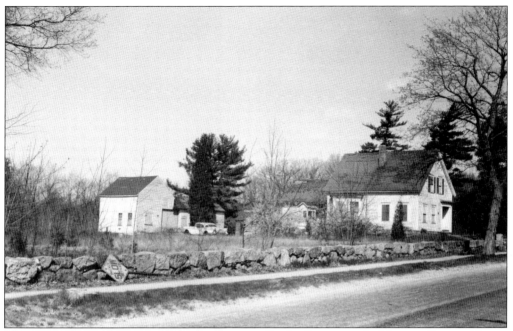

The Waite's house and barn on Pleasant Street in Rockville is typical of this small area of farms. The farm is located adjacent to the Ellice School. In later years, Flossie Johnson occupied the house. She remembers that the Ellice School teacher would have lunch with her mother, Florence "Flossie" Waite, at the house.

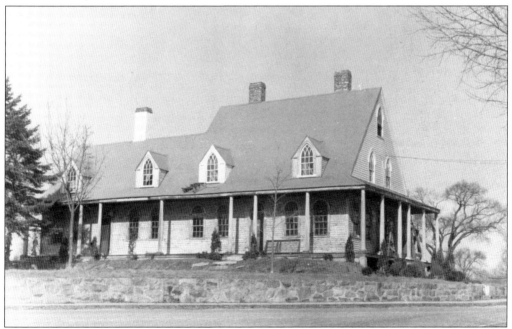

The house that stands on the corner of Myrtle and Pleasant Streets was built by Horace Dean Walker and was known as "Walker Castle." Dean Walker was a mill owner and local industrialist. He moved the third meetinghouse to the Deanville section for use as a lace mill, but the mill was never established.

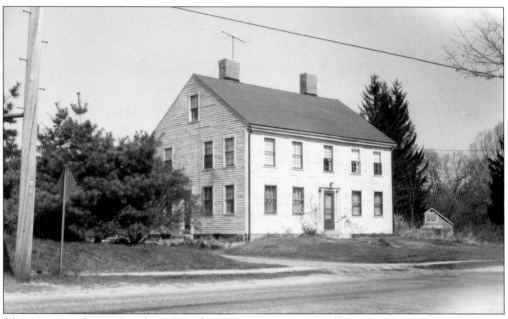

The Simmons house stands at 247 Pleasant Street in Rockville. Joe Simmons was the letter carrier in Rockville in the years around 1900. He would drive his wagon to the Millis Train Depot twice a day, except Sunday, and deliver the mail to the Rockville store. Rockville residents could ride with him to Millis for 25¢. Joe was also known for the hard cider he produced on his seven-acre farm.

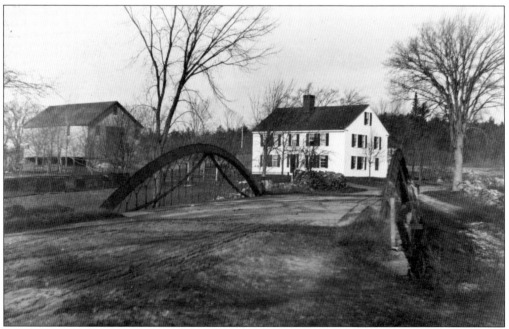

What Walter Prescott called the Red Iron Bridge replaced the wooden bridge that crossed the Charles River at Myrtle Street. In July 1918, the bridge was accidently destroyed by a crew working on the road. It was replaced by a concrete bridge. River End Farm is in the background. (Courtesy of Wayne Simpson.)

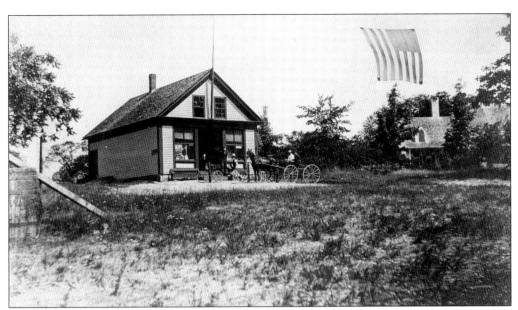

The Rockville Store and post office stood on Myrtle Street across from where the Rockville Fire House now stands. For many years, Fredrick Swarman operated the store. A Civil War veteran, Swarman had lost an arm in the Battle of Antietam, according to Walter Prescott's journal. The flag was purchased by the people of Rockville and flew over Myrtle Street for many years. (Courtesy of Hindy Rosenfeld Collection.)

Walter Prescott describes Rockville as "a very quiet place at all times, every day being like Sunday. The steam whistle on the felt mill breaks the calmness four times a day except on Sunday." In this 1902 photograph, Curtis Parrish is cutting John Cribbies's hair while Jake Corbett looks on. The parrot is unidentified. (Courtesy of Wayne Simpson.)

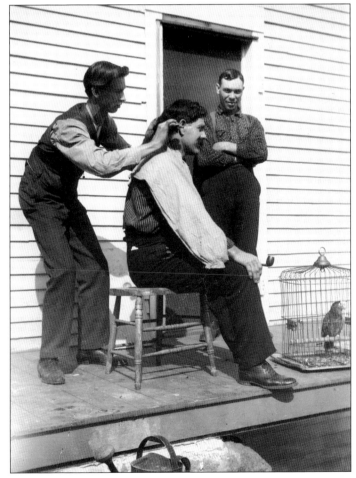

Years ago, recreational swimming meant cooling off in a nearby river or in a pond. "Old Sawdust Bottom" is what Walter Prescott called this spot on the Charles River where there was a swimming hole. Fishing was not particularly good on the Charles; it consisted of hornpouts, pickerel, suckers, and eels. (Courtesy of Wayne Simpson.)

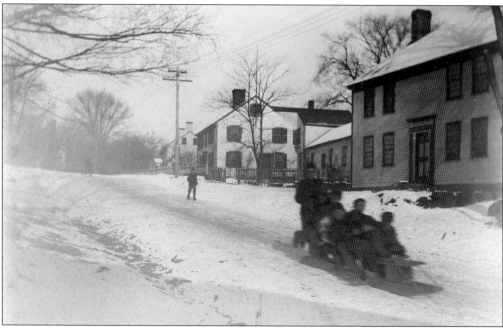

Prescott thought nearby Kingsbury Pond in Franklin was the best swimming hole. It was, however, a dangerous place for skating, since it was spring-fed. Ice skating was good above the Rockville Dam. Another form of winter fun was sledding. This group of children is sledding down Pleasant Street from the intersection with Myrtle Street towards the bridge in 1903.

Eight

ABOUT TOWN

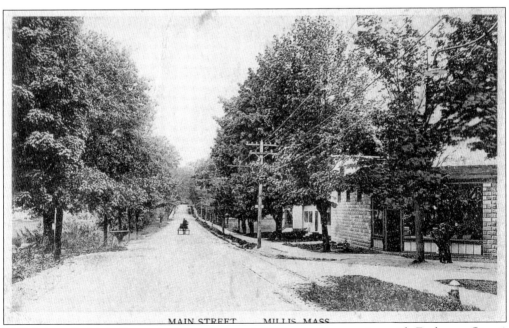

Millis's bucolic Main Street is pictured around 1900 at its intersection with Exchange Street. The trolley tracks run up the right side of the road. The building on the corner was torn down in 2011 to make way for a new public library. (Courtesy of Harold Curran.)

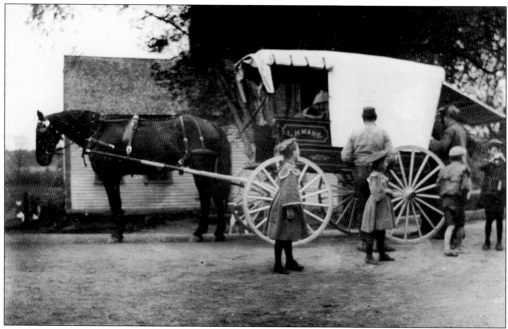

Even before the advent of the automobile, storekeepers made deliveries to surrounding towns. For example, the proprietor of the Rockville Store would take and deliver orders in the towns of Medway, Millis, Norfolk, and North Franklin. Pictured on May 16, 1899, is the L.H. Ware Butcher delivery wagon near Waite's Mill in Rockville. (Courtesy of Wayne Simpson.)

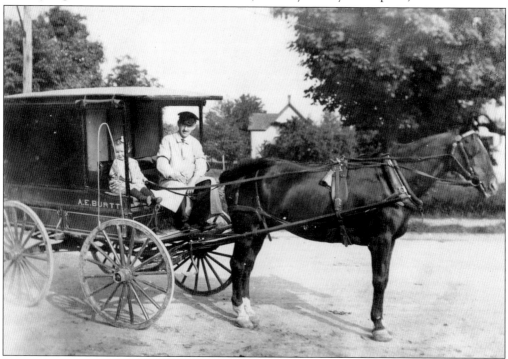

Pictured is grocer A.E. Burtt's wagon. He operated a store on Exchange Street near the Niagara Fire Engine House for many years. (Courtesy of Harold Curran.)

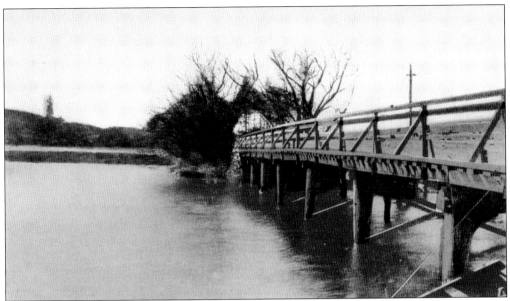

Depicted on this postcard is the Main Street Bridge over the Charles River looking west towards Millis. The wooden structure was both a highway and a trolley bridge. The electric trolley cars were run for the first time from Dedham to Thorne's Corner in Millis on February 3, 1900. (Courtesy of Hindy Rosenfeld Collection.)

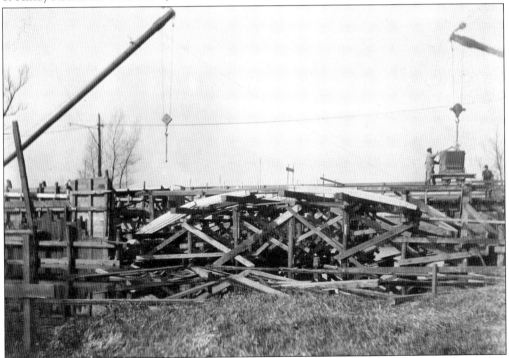

Bridge construction is pictured over the Charles River on the Millis and Medfield town line. The concrete construction necessitated the extensive shoring and form work shown here. The booms of two stiff leg cranes are visible. One crane was set up on each side of the river. This concrete bridge replaced the wooden highway bridge. (Courtesy of Harold Curran.)

for Electric Railroad

A small shanty does duty for a public waiting
room at the four corners or Rockville Corner (so called)
It is a what might be called a large box, there is a
door way & no door, one small window toward track,
and a board on back side running full length for
a seat, which is seldom used.

In winter it breaks off the bad North East winds
& storms, also keeps off the rain.

It is located on East side of track, on the Boston
Place. An electric light is maintained by electric
road at this place or corner.

[diagram showing Medway, Millis North, Medfield, Rockville car station, dotted line road on elec. car line]

Electrical Railroad, — Know by name as
the Norfolk Western & Medfield & Medway Street Railroad Co.
Fare to Medway or Medfield from any
part of Millis .5 cents! and 5¢ to every
town the cars pass through,

In the month of July I first
noticed, that the Co. issued a
ticket for an excursion trip good
only for the month printed on card.
A round trip of 43 miles for 25¢&
is a 3 hours ride except on holidays & Sundays, and
must stay on same car!

August ticket cards are blue. Can
be got of conductors and have received
one at Rockville store.

The road was built without any
serious delay, after char franchise
was granted and —

The first car run for passengers was
run on Sunday

Many of the open cars have air brakes
and air whistles.

Single track from Dedham & Franklin with tour turnouts
for every 15 minutes run, one is located about 500 feet North
of the Rockville corner, another about the same distance
east of Thorne corner in Millis.

A description from a page in Walter Prescott's journal describes the Norfolk and Medfield Street Railway Company. Prescott writes, "Time to reach Sullivan Square in Charlestown, from Rockville Corner, just two hours, total fare 25 cents. This being accomplished by having good connections." (Courtesy of Wayne Simpson.)

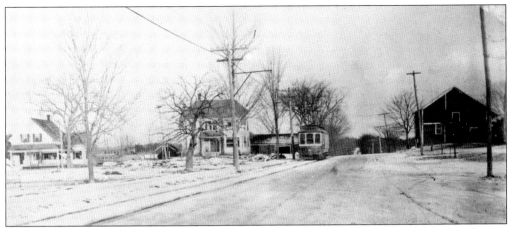

This 1908 photograph shows a trolley traveling west through the intersection of Plain and Main Streets. The house to the left of the trolley is Thorne's farmhouse, now Harkey's Realty. The barn across the street is on the present site of the Maurer Building. (Courtesy of Harold Curran.)

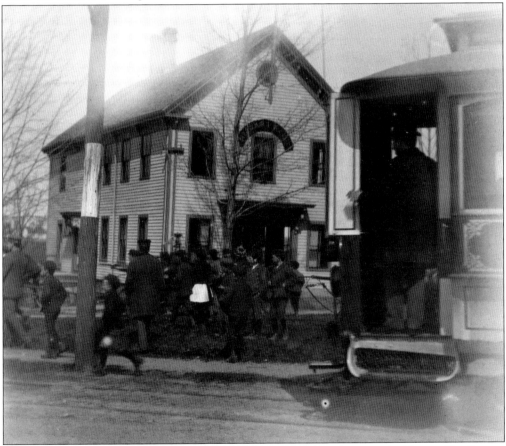

According to Walter Prescott's notes on this photograph, he was shooting the Niagara Fire Engine House when the trolley got in the way. The photograph was taken on April 19, 1902, or Patriot's Day holiday. Massachusetts started commemorating the battle of Lexington and Concord in 1894. The white band on the pole marks a trolley stop. (Courtesy of Wayne Simpson.)

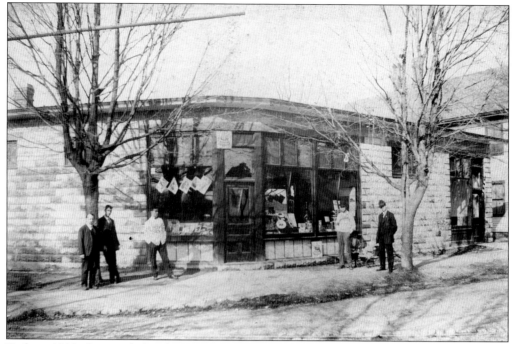

Built in 1916, this rough-faced, concrete-block building wrapped the corner of Exchange and Main Streets. The building was known as the Patent Medicine Store, later Rexall Drugs. After the drugstore businesses closed, the building housed a variety of retail shops and offices. The building was torn down in 2011 to make way for the new Millis Public Library.

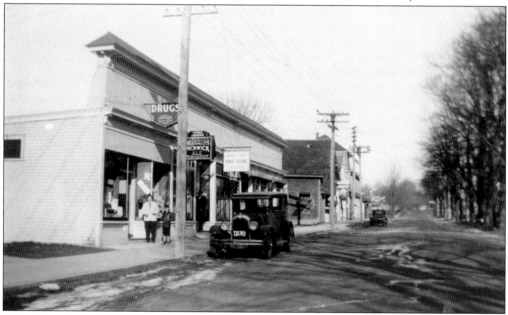

This view shows Abe Margolis's Millis Pharmacy on Exchange Street. One of the pharmacy's advertisements states, "We serve Neopolitan Dutch Girl quality ice cream at our fountain." Next to the pharmacy are Condon's Package Store, Morris Starr's Shoe Store, and Burtt & Crowther's Grocery Store. Beyond is Snow's Hall and the opera house, or Thorne's Block.

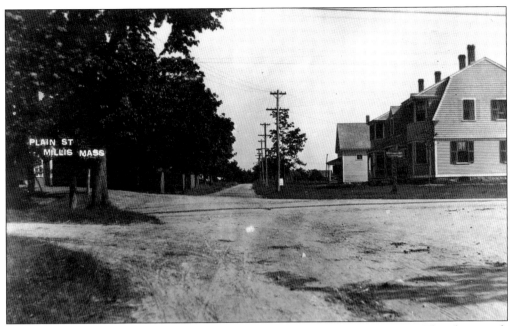

Thorne's Corner in Millis is located at the intersection of Plain and Main Streets. This photograph is looking north. The house on the northeast corner is Thorne's farmhouse. In later years, the corner opposite the farmhouse would be occupied by a gas station. (Courtesy of Harold Curran.)

The cottages located in the foreground of this 1901 photograph stand on Parnell Street. The next row of houses sits on Adam Street. Henry Millis's company built these homes in 1890. Beyond are the Herman Shoe Company and the Steel Edge Factory. (Courtesy of Wayne Simpson.)

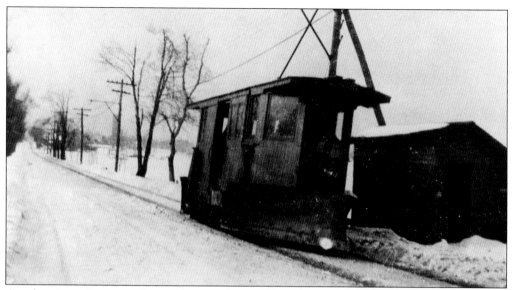

An electric trolley snowplow is clearing the tracks in front of the Clicquot Club complex on Main Street. On the hill in the distance is the water tower, which is on the current police and fire station site.

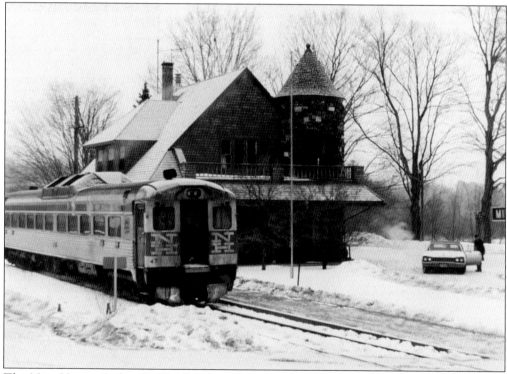

The New Haven Railroad's Charles River Line ran from West Roxbury, Massachusetts, to Woonsocket, Rhode Island. This photograph depicts a passenger Budliner stopped at the Millis train station and town hall in the 1960s. Starting in July 1927, the New Haven ran its first unit freight train, the Ginger Ale Express. This freight train operated from Millis to Lowell for the Clicquot Club Ginger Ale Company. (Courtesy of Hindy Rosenfeld Collection.)

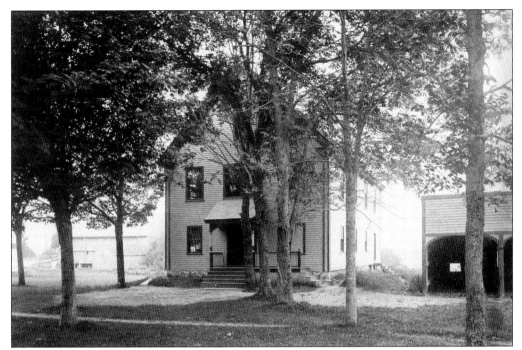

The National Grange of the Order of Patrons of Husbandry, or Grange, was established in 1867. The organization promoted agriculture and became a powerful lobbying group in the later part of 19th century. The East Millis Grange chapter started in 1883. In 1893, Grange Hall was built on land that is now the parking area of the Church of Christ.

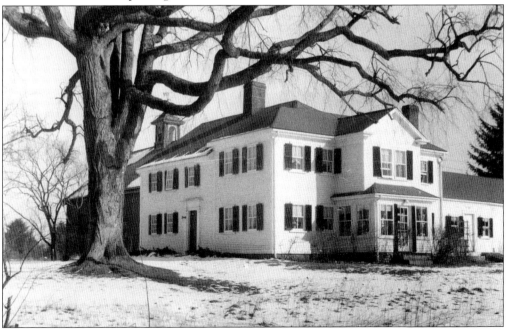

This photograph shows the Jonathon Adams house on Main Street. The house was built around 1700. It is located on part of the original land grant given to Jonathan's grandfather Edward in 1672. Jonathan was one of the petitioners to incorporate Millis.

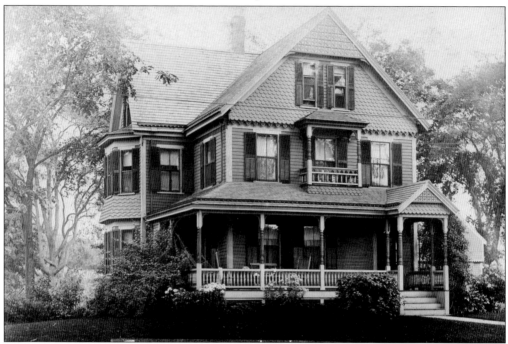

In Millis, a few houses and one church were built prior to 1852, but most were constructed in the late-19th and early-20th centuries. Nearly all the buildings are of wood-frame construction. The Clark House is located on Main and Spring Streets. It occupies the site of the Holbrook Bell Factory.

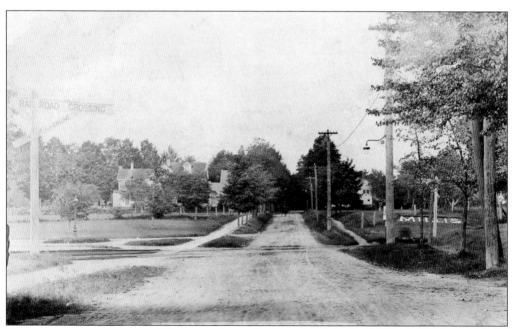

Shown is a picturesque view of Exchange Street. St. Thomas Church now stands in the grassy area to the left. The driveway on the left, adjacent to the railroad tracks, leads to the Lansing Millis Memorial Building. Lavender Street is to the right. (Courtesy of Hindy Rosenfeld Collection.)

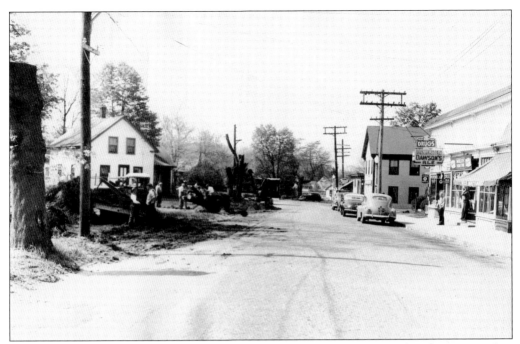

Exchange Street was widened in 1949. The white house on the left belonged to the Payson's. It is said to have been the first home in Millis to be electrified. The large shade trees that had lined the street are being taken down. (Courtesy of Edward Shropshire.)

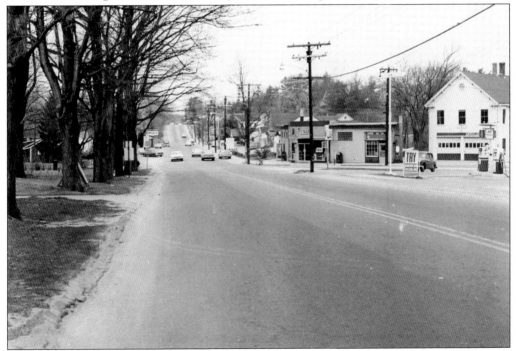

This c. 1960 photograph shows Main Street Millis looking west. Main's Rexall Drug is located on the corner of Exchange and Main Streets. The right half of the building housed the offices of the Howie Oil Company. The American Gas Station on the right is now an automobile repair garage.

The opera house, which was constructed by Henry Millis's company in 1894, was located on Exchange Street. Also in 1894, the Millis Company went bankrupt, and the building was auctioned off for $1,000. In 1899, the Thorne brothers purchased the building and moved the Thorne Bros. Coal and Grain Company to the location. (Courtesy of Harold Curran.)

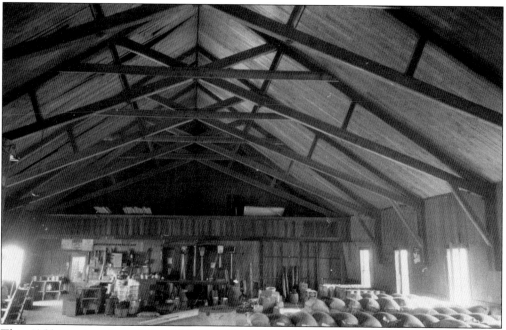

This 1955 interior view of the old Thorn Bros. Coal and Grain Company shows grain sacks and tools stored in the rear section of the building. The Thorne block was demolished in the early 1970s.

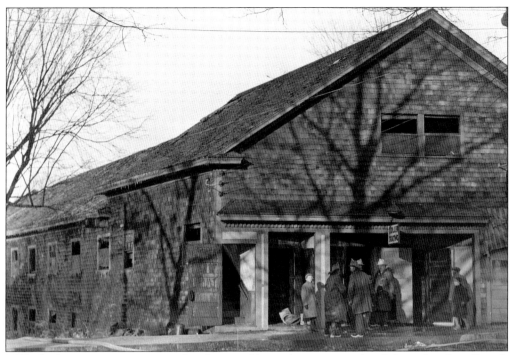

Millis had no space to accommodate large public gatherings outside of their churches. Snow's Hall was a multi-purpose use of space. Uses included roller skating, dances, high school sporting events, prize fights, and even Millis town meetings. It was located on Exchange Street near the opera house. The hall burned on December 8, 1934. It was replaced in 1935 with a one-story brick commercial building known as the Winiker Block.

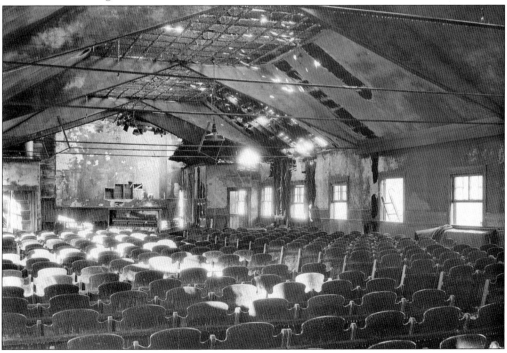

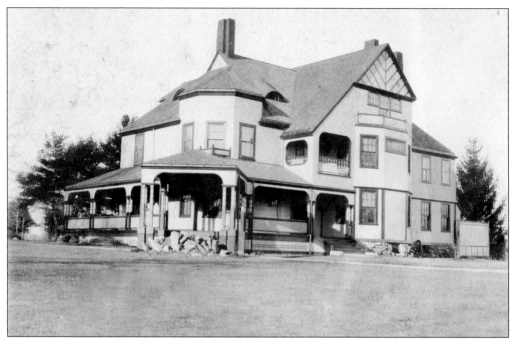

Rocklawn was built by Lansing Millis for his daughter Helen VanKleek in 1887. In 1920, the Cole family purchased the house. For many years, Eleanor Cole ran a popular gift shop called the Holiday Shop in her home.

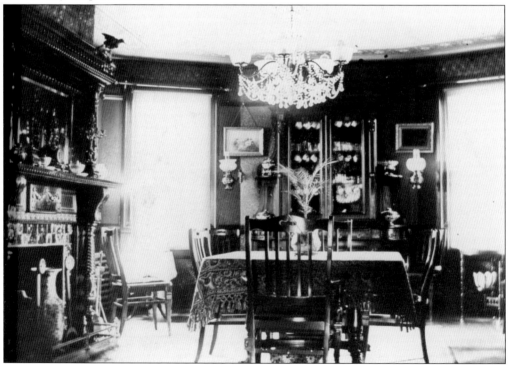

The interior of Rocklawn shows the opulence of the era when it was used as a private home. In recent years, the house has been used as a restaurant. Much of the original interior woodwork remains.

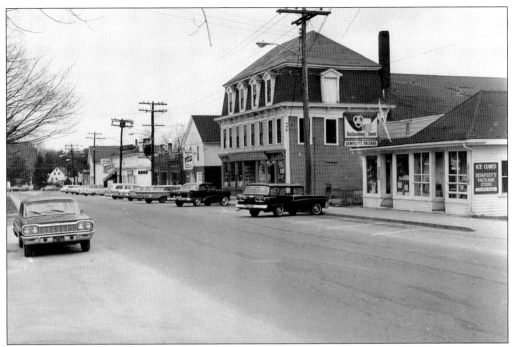

This c. 1950 photograph shows Exchange Street. The Package Store has operated under several different ownerships, including the Fishers, Dempsey's, Lewis's, and Lumpy's Liquors. An automobile parts store is located in the old opera house. The opera house was torn down not long after this photograph was taken. The site of the old opera house is now a parking lot.

Fuller's Department Store, Millis, Mass.

Shown is an early postcard of Fuller's Department Store, which was located at Holbrook Square at the intersection of Exchange, Curve, and Plain Streets. In earlier times, the area was known as Church Square because of its proximity to the Church of Christ. (Courtesy of Hindy Rosenfeld Collection.)

This 1935 photograph was taken of the Millis Girl Scout Drum and Bugle Corps marching by Warner Holbrook's Grocery Store in Holbrook Square. The event was a parade for the celebration of the 50th anniversary of the founding of Millis. Warner Holbrook retired in 1946 after 36 years of running the grocery store.

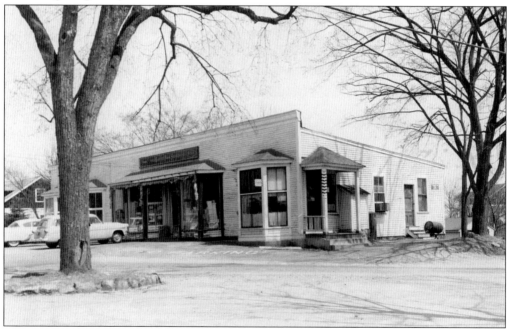

In the 1950s, a Clover Farm Store occupied the Holbrook block. Curran's Barber Shop occupied the left-hand side of the building. In the 1930s, there was a pot-bellied stove and spittoon in the barbershop. The elm tree on the right-hand side stood for many years on a traffic island in the middle of the intersection.

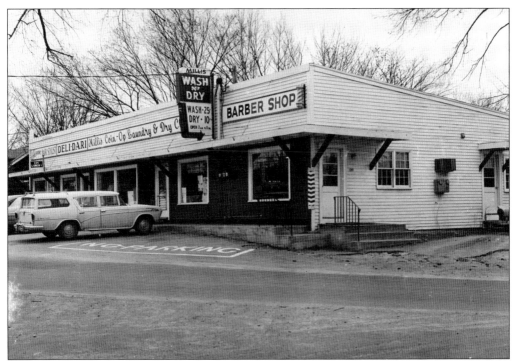

Four businesses occupied Holbrook Square in the 1950s. From left to right are Gwenn Hair Stylist, Ed's Lunch and Deli-Dari, Millis Coin-Op Laundry, and Curran's Barber Shop. The long triangular common, Memorial Park, is located directly across Curve Street from this building. The park is where commemorative programs are held each year on Memorial Day and Veterans Day.

A large piece of quartz is being set for the war memorial in Holbrook Square. The stone came from a rock outcropping off Main Street at the Millis and Medway town line. Ray Simpson is pictured with the shovel along with a helper and two boys preparing to set the stone in 1935.

Shown is the completed war memorial in the late 1930s. The memorial is located directly across the street from the American Legion Post 208 and commemorates veterans from the Revolutionary War, War of 1812, Mexican War, Civil War, Spanish-American War, and World War I.

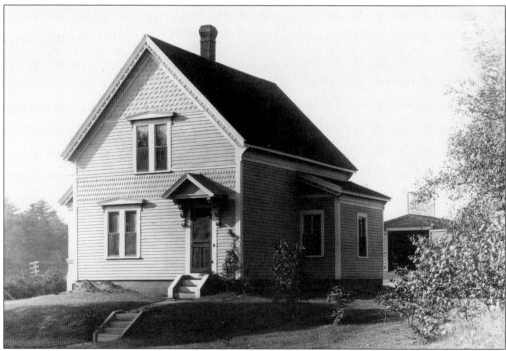

The Bicknell house is located on Union Street opposite Parnell Street. The old wooden Adams Bicknell garage can be seen behind the house. It is said that this house was the first one built in Millis after its incorporation. Currently, it has been transformed into a rest home.

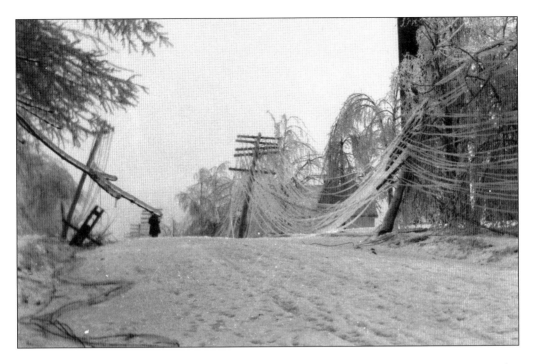

Many dwellings survive from the 1890s, a time when several industries were established nearby. The Millis Company financed the construction of approximately 60 cottages. New streets were laid out, including Lavender and Irving Streets. When the Millis Company went bankrupt in 1894, Dr. Charles W. Emerson purchased the seven cottages on Lavender Street for $4,300. These photographs show Lavender Street after the 1921 ice storm. The photograph above is looking north. The standpipe on the left is where the current police and fire station now stand. The photograph below is a view looking south with the opera house in the distance. (Photograph below courtesy of Edward Shropshire.)

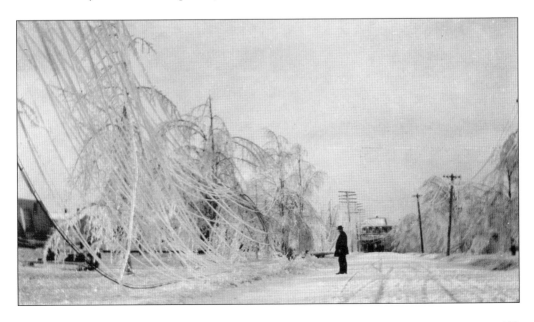

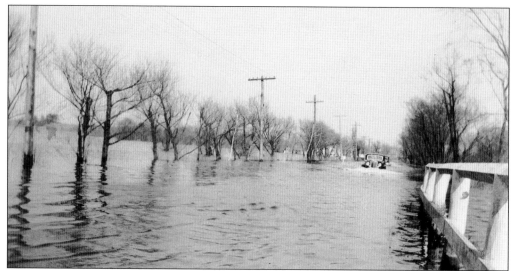

The Charles River overflowed during a flood in March 1936. Route 109, pictured, was closed for a time. Water also ran over Route 115 (Orchard Street) at the Boggastowe dam. (Courtesy of Edward Shropshire.)

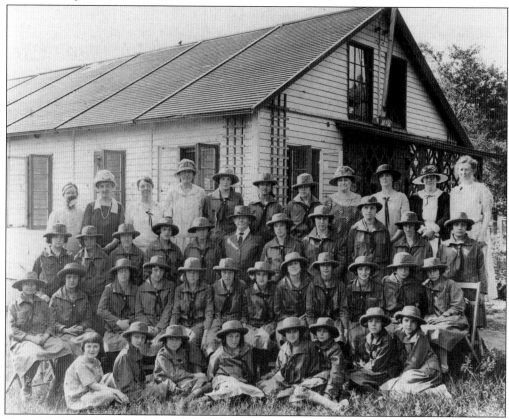

Flora B. Mundy, director of the Millis Girl Scouts, was responsible for bringing the Scout House from Boston to her farm on Dover Road. It was later relocated to the Church of Christ and eventually moved to Oak Grove Farm. The Scout House was destroyed by arson in the 1990s.

During the 1920s, plots of land measuring 25 feet by 50 feet in the area called Millis Heights were given away as raffle or bingo prizes at several Jewish hotels. Millis Heights is located in the area of Congress and Federal Streets and George Avenue off of Pleasant Street.

This c. 1960 photograph of Main Street shows, from left to right, the Sunshine Dairy (later Farnum's Restaurant) Harris's Mobile Station, St. Thomas Large Hall, and Thelma's Restaurant. Thelma's Mickey Mouse Restaurant later became known as Norman's Nook, an antique shop, which burned down in the 1990s.

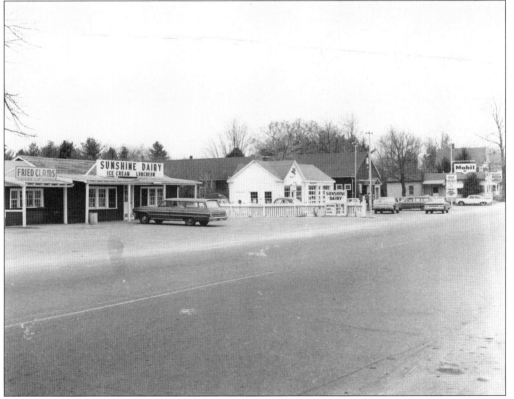

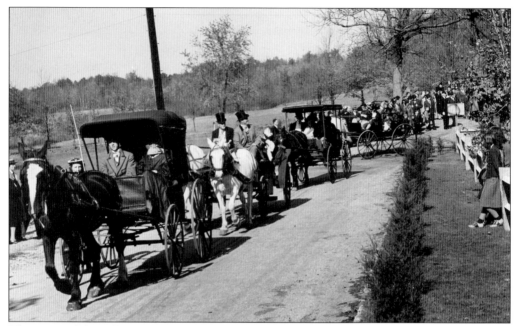

The town celebrated its 50th anniversary of incorporation in 1935. Residents dressed in period costumes and paraded in horse-drawn carriages on May 30, 1935. It is estimated that 8,000 people attended the parade and dedication at Memorial Park, and 7,000 people attended the evening band concert and fireworks.

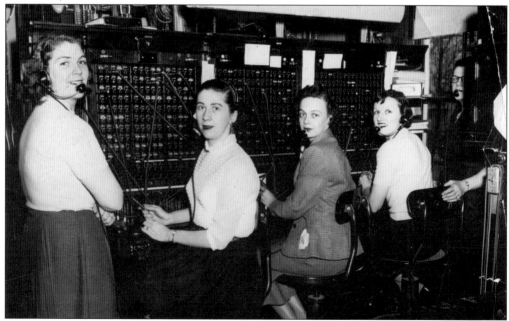

The telephone switchboards were located at 29 Exchange Street. Among the telephone operators are Helen Ward (third from left) and Roma King Curran (fourth from left). Residents would call the switchboard in an emergency. The operators would then switch on a red light that hung on a cable over Main Street at Exchange Street. When a police officer saw the red light, they checked in with the operators.

Before the present-day police and fire station was built, the police used the back of the Niagara Fire Engine House for their station and jail. This 1936 photograph shows the back of the building after the fire with the bars on the jail windows.

This 1939 photograph depicts Chief Scholl on the left and Bill Thorne on the right. Chief Scholl was hired as Millis's first police officer. Prior to this, the town had part-time constables for protection. Chief Scholl died in 1947. Bill Thorne was the town constable and truant officer. Constable Thorne started his 52nd year of service 1941. He died on May 10, 1943.

DISCOVER THOUSANDS OF LOCAL HISTORY BOOKS
FEATURING MILLIONS OF VINTAGE IMAGES

Arcadia Publishing, the leading local history publisher in the United States, is committed to making history accessible and meaningful through publishing books that celebrate and preserve the heritage of America's people and places.

Find more books like this at
www.arcadiapublishing.com

Search for your hometown history, your old stomping grounds, and even your favorite sports team.